FABERGÉ The Imperial Eggs

S0-BFB-573

$5⁰⁰
b

San Diego Museum of Art
Armory Museum, State Museums of the Moscow Kremlin

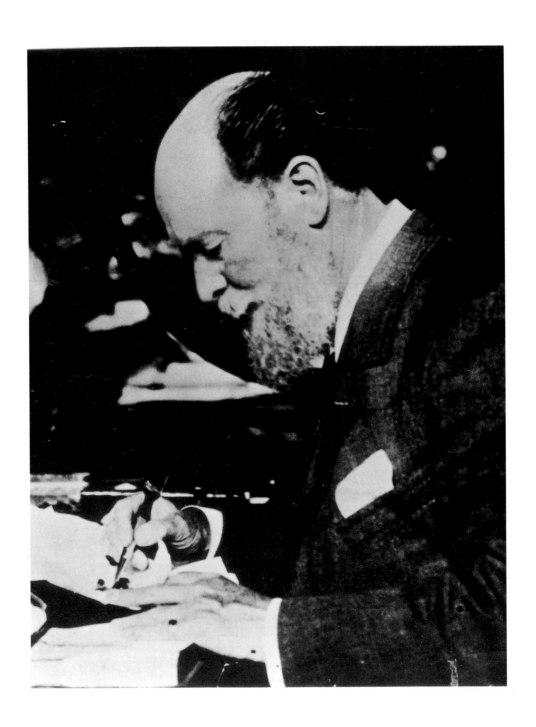

FABERGÉ

The Imperial Eggs

With essays by
Christopher Forbes, Johann Georg Prinz von Hohenzollern,
and Irina Rodimtseva

San Diego Museum of Art
Armory Museum, State Museums of the Moscow Kremlin
in association with Prestel

FABERGÉ: THE IMPERIAL EGGS,

an exhibition organized by the San Diego Museum of Art,
is made possible by a gift from the Hibben Fund
of the San Diego Community Foundation

Published in conjunction with the exhibition *Fabergé: The Imperial Eggs,* held at the
San Diego Museum of Art (October 22, 1989–January 7, 1990) and the Armory Museum,
State Museums of the Moscow Kremlin (January 30–March 15, 1990)

Translation from the German: Bram Opstelten
Translations from the Russian: Barbara Chronowski

© 1989 San Diego Museum of Art and Prestel-Verlag, Munich

Front cover: Madonna Lily Egg, 1899,
Armory Museum, State Museums of the Moscow Kremlin (plate 10)

Back cover: Coronation Egg, 1897,
The Forbes Magazine Collection, New York (plate 7)

Frontispiece: Peter Carl Fabergé sorting a parcel of stones, circa 1915

Prestel-Verlag
Mandlstrasse 26
D-8000 Munich 40
Federal Republic of Germany

Distributed in continental Europe and Japan by Prestel-Verlag,
Verlegerdienst München GmbH & Co KG, Gutenbergstrasse 1, D-8031 Gilching,
Federal Republic of Germany

Distributed in the USA and Canada by te Neues Publishing Company, 15 East 76th Street,
New York, NY 10021, USA

Distributed in the United Kingdom, Ireland, and all other countries by Thames & Hudson
Limited, 30–34 Bloomsbury Street, London WC IB 3QP, England

Design: Norbert Dinkel, Munich
Separations and lithography: Brend'Amour, Simhart GmbH & Co., Munich
Typography, printing, and binding: Passavia Druckerei GmbH, Passau
Printed in the Federal Republic of Germany

ISBN 0-937108-09-x (softcover edition, not available to the trade)
ISBN 3-7913-1027-5 (hardcover trade edition)

Contents

Foreword

"A miracle" is how Malcolm Forbes described the agreement permitting the Fabergé imperial eggs from the Armory Museum, State Museums of the Moscow Kremlin, to be exhibited with the Forbes Magazine Collection of imperial eggs from New York – all in San Diego!

"A miracle" is how I describe the Soviet decision to permit this display to travel to Moscow and become the *first* foreign exhibition ever presented inside the Kremlin walls.

Such miracles are rare in anyone's lifetime.

Usually they are heralded by angels. San Diego's civic "angels," Helen and David Copley and Joan Kroc, announced their support for San Diego's first Arts Festival: Treasures of the Soviet Union, with alacrity and generosity.

Such miracles also depend on the faith of a handful of people who believe in beauty, art, culture, and goodness.

San Diego is blessed with many such people – in particular, Joseph Hibben, who believed enough to underwrite the Fabergé exhibition; Jane Rice and Mary Stofflet, who believed enough to persevere when fainter souls had faded; and Doug Byrns, Dan Pegg, and Christopher Forbes, who dared to dream that this unprecedented exhibition could become a reality.

Special mention goes to the Queen of England, Her Majesty Elizabeth II, The Cleveland Museum of Art, and The Matilda Geddings Gray Foundation Collection for their loans of Fabergé imperial eggs to the exhibition.

To them, to the San Diego Museum of Art's board of trustees, the farsighted members of the San Diego City Council, and John Lockwood, our dedicated City Manager, I credit this miracle.

The Soviets, too, produced their believers. Three Irinas: Irina Rodimtseva, Irina Polinina, and Irina Mikheyeva, without whom the reunion of the Fabergé eggs and the later exhibition inside the Kremlin walls could not have happened.

The three Irinas, with their American counterparts, have recreated the centuries-old Russian Easter tradition of faith – the gift of "three kisses and an egg" – a miracle that we all invite you to enjoy once in your lifetime in the City of San Diego.

Finally, a special thank you to the Ronald McDonald Children's Charities for providing the funding to admit children to the exhibition free.

Experience the miracle.
Witness the history.
Behold the art.
And enjoy San Diego.

Maureen O'Connor
Mayor, City of San Diego

Introduction

It is both ironic and revealing that what eventually became the dazzling symbol of an opulent and resplendent era is, in its purest form, one of nature's most unadorned and perfect components.

From the dawn of recorded time, the egg has been a symbol of birth and ultimate resurrection. Egyptians carefully nestled them beside the sarcophagi of the entombed, the Greeks reverently placed them atop graves, the Romans penned odes to their miraculous qualities of life and birth. The early Christian church honored the egg when it attributed the responsibility for carrying Jesus's cross to a lowly egg merchant who, upon returning to his farm, discovered the eggshells to have taken on miraculous rainbows of colors.

The egg has retained an important cultural role throughout history. Eggshells were painted with religious subjects as early as the thirteenth century. In the early sixteenth century, François I of France was presented an eggshell containing a wooden carving of the Passion and the custom of exchanging elaborate Easter eggs was born.

Gilded and painted eggs were frequently presented in royal courts, and some of France's most esteemed artists, such as Watteau, Boucher, and Lancret, were commissioned to decorate shells.

But, of course, the name most associated with the highest art form of the resplendent egg is Peter Carl Fabergé, whose dazzling works constitute this exhibition. It is surprising to note that, since the practice in Russia of exchanging eggs at Easter was banned after the Revolution, the Fabergé eggs, so acclaimed and admired abroad, were little known in pre-perestroika Russia.

Like all international exhibitions, this presentation is the result of countless individual efforts and an extraordinary commitment made by a number of generous persons.

The exhibition was conceived by the Mayor of San Diego, California, the Honorable Maureen O'Connor. Her enthusiasm for the project was boundless, and she deserves special recognition for her efforts.

We are also deeply grateful to the Museum's President, Joseph W. Hibben, and his wife, Ingrid, for their support of the exhibition through a generous gift from the Hibben Fund of the San Diego Community Foundation.

The San Diego Museum of Art staff, as always, handled the mountain of details which such a complex challenge provides with dispatch and enthusiasm. Curator Mary Stofflet, Deputy Director Jane Rice, Head of Publications and Sales David Hewitt, Head of Design and Installation Mitchell Gaul, Assistant Designer Michael Field, Chief of Security and Building Superintendent Robert Kimpton, Curator of Education J. Barney Malesky, and Public Relations Coordinator Mardi Snow all deserve congratulations and thanks.

The cooperation of Irina Mikheyeva, Department of Foreign Relations, USSR Ministry of Culture, Irina Rodimtseva, Director, State Museums of

the Moscow Kremlin, and Irina Polinina, Head of the USSR Diamond Fund, State Museums of the Moscow Kremlin, and coordinator of the exhibition, has been invaluable in completing the arrangements for the project.

We also wish to thank Malcolm S. Forbes, Chairman, Chief Executive Officer, and Editor in Chief, *Forbes Magazine;* Christopher Forbes, Vice Chairman, *Forbes Magazine;* Margaret Kelly, Curator, The Forbes Magazine Collection; Mary Ellen Sinko, Assistant Curator, The Forbes Magazine Collection; Maryclaire Donovan Frank, General Counsel, *Forbes Magazine;* John W. Keefe, Curator of Decorative Arts, New Orleans Museum of Art; Henry Hawley, Chief Curator, Later Western Art, The Cleveland Museum of Art; R. Esmerian, Inc., New York; and Vartanian & Sons, Inc., New York, for their tireless and willing efforts in coordinating innumerable details.

Barbara Chronowski provided the English translation of the Russian texts and Bram Opstelten that of the essay by Johann Georg Prinz von Hohenzollern. The translations into Russian for the Russian edition of the catalogue were provided by Dr. Veronica Shapovalov.

Special thanks are due as well to A. Kenneth Snowman, London, Alexander von Solodkoff, London, and Johann Georg Prinz von Hohenzollern, Director, Bayerisches Nationalmuseum, Munich.

We trust this exhibition will offer a rare and important opportunity for visitors to view and study these remarkable objects assembled together for the first time. For such an exciting occasion, all of the many people who worked so tirelessly on its behalf are to be congratulated.

Steven L. Brezzo
Director, San Diego Museum of Art

Johann Georg Prinz von Hohenzollern Fabergé: The Imperial Easter Eggs

Unfortunately, very little information exists about where the imperial Easter eggs were kept in the various palaces in and outside of St. Petersburg prior to the imprisonment of the czar and his family in 1917. The same applies to the other imperial *objets d'art* from the Fabergé workshop. The present essay is based mainly on research published by various authorities on Fabergé and his art.[1] According to these authors, Fabergé created a total of fifty-six imperial eggs for Czar Alexander III and, after Alexander's death in 1894, for Czar Nicholas II. A further twelve Easter eggs were designed for Alexander Ferdinandovich Kelch, owner of several gold mines in Siberia, for Prince Yussupov, and for the Duchess of Marlborough. Although they rival the imperial eggs in quality, these additional eggs will not be dealt with here.[2]

Considering how dearly the Dowager Czarina Marie Feodorovna and Czarina Alexandra Feodorovna must have treasured these exquisite, costly Easter gifts, with their various surprises, one would like to think that the eggs were kept in showcases, where they could be admired by relatives and guests. Or were these marvels of gold smithery, which cost a fortune to produce and which, because of their complicated mechanisms, could not be set in motion too often, kept in safes and displayed only around Easter time? Be that as it may, Alexander von Solodkoff mentions that, after the Revolution and the execution of the imperial family, only the Cross of St. George Egg (plate 26; no. 45, p. 114) left Russia in the hands of its original owner, the Dowager Czarina.[3]

After 1917 the entire property of the imperial family was confiscated by the Soviets and inventoried over a period of several years. Alexander Polovtsov, superintendent of Gatchina Palace, and George Lukomsky, who was responsible for the palaces in Czarskoe Selo (present-day Pushkin) until 1918, have left behind accounts of events at that time. However, these contain no information on the whereabouts of the imperial eggs or on where they had been kept. The descriptions of the private rooms of the imperial family in Gatchina Palace and in the palaces in Czarskoe Selo, which included Alexander Palace, do not mention objects by Fabergé. The private suite of the last czar actually seems to have been rather plain and that in Alexander Palace was apparently furnished in the art nouveau style. One reason for the lack of any reference to Fabergé objects may be that they had already been removed from the palaces. Lukomsky relates that all valuables belonging to the imperial family were packed into trunks in the spring of 1918 with the intention of transporting them to Moscow after provisional storage in the Winter Palace in St. Petersburg. Among the objects mentioned by Lukomsky in this connection are centerpieces and Easter eggs.[4]

In recent years, the period of historicism, with its varied stylistic manifestations, has become the object of scholarly research and its achievements,

◁ Coronation Egg, 1897. Detail.
(See plate 7)

1. The chief works consulted were Geza von Habsburg-Lothringen and Alexander von Solodkoff, *Fabergé: Court Jeweller to the Tsars* (New York, 1979); Alexander von Solodkoff et al., *Masterpieces from the House of Fabergé* (New York, 1984); and Geza von Habsburg, *Fabergé: Hofjuwelier der Zaren,* exhibition catalogue (Munich, 1986).
2. See Habsburg and Solodkoff, 1979, pp. 109 ff. and 158, which includes a list and illustrations of these eggs.
3. Solodkoff et al., 1984, p. 84 f.
4. Ibid., p. 106.

particularly in the applied arts, have been accorded due recognition. Works of art fashioned in the romanesque, gothic, renaissance, baroque, and rococo styles, whether perfect copies or sensitive interpretations, were still regarded with contempt and sold far under value a generation ago. Today, they are coveted collector's items. Like art nouveau pieces in the last decades, objects created during the period of historicism now fetch top prices on the art market.

On the other hand, Fabergé's *objets d'art* or *objets de fantaisie*, which belong chronologically and stylistically to historicism, have always been highly regarded and in great demand, with the exception of a short period following World War I. Made of the most precious materials, such as gold and platinum, coated with the most exquisite kinds of enamel, and studded with gems, these works of art tended to be considered as pieces of jewelry. The imperial dynasty and its numerous royal and princely relatives – the English, the Danish, the Greek, the Bulgarians, the Hessians, and the Hannoverians – who received many Fabergé objects as presents from the Russians, treasured them highly and were careful to bequeath them to the next generations.[5] Such presents generally consisted of small everyday objects – cigarette cases, umbrella handles, writing utensils, picture frames, table clocks, and the like. These most exquisitely crafted works of art were in fact used. Families lived with them. I myself recall such objects – among them carved hardstone animals – standing around in private homes. Relatives offered me cigarettes from precious Fabergé cases and, at Easter, women wore long necklaces strung with numerous small Easter eggs fashioned by Fabergé or his workmasters and successors. Unfortunately, when the prices for these *objets d'art* boomed, they disappeared into safes. Many of these previously unknown, privately owned pieces were shown at the major Fabergé exhibition that took place at the Hypo-Kunsthalle in Munich from December 1986 to March 1987. Apart from royalty – the King of Siam, for example – several rich businessmen, such as Kelch and Alfred Nobel, the inventor of dynamite, were among Fabergé's best customers.

When the monarchies collapsed after World War I, reducing the European aristocracy to poverty, many Fabergé objects were put up for sale and passed into other hands. Then, in the 1920s, a lack of foreign currency forced the Soviets to start selling works of art from the state collections – among them, the majority of the imperial eggs. American and British collectors and art dealers took particular advantage of this situation, and it was they who established the great popularity of Fabergé's art in the United States and Great Britain. On the other hand, Fabergé remained comparatively little known in Central Europe and some of its bordering countries until the Munich exhibition in 1986 and until the news coverage afforded the American publisher Malcolm Forbes and his passion for collecting Fabergé's work. In Britain, it was above all the firm of Wartski that made Fabergé famous after World War II, by arranging several minor exhibitions and trading important pieces. The well-known Fabergé collection of the British royal family naturally had a share in this. These pieces had been acquired for the most part by Queen Alexandra, the wife of Edward VII and sister of Czarina Marie Feodorovna, partly in the form of presents, partly by directly commissioning the Fabergé workshop. The collection, which today encompasses more than four-hun-

5. Habsburg, 1986, p. 17 ff.

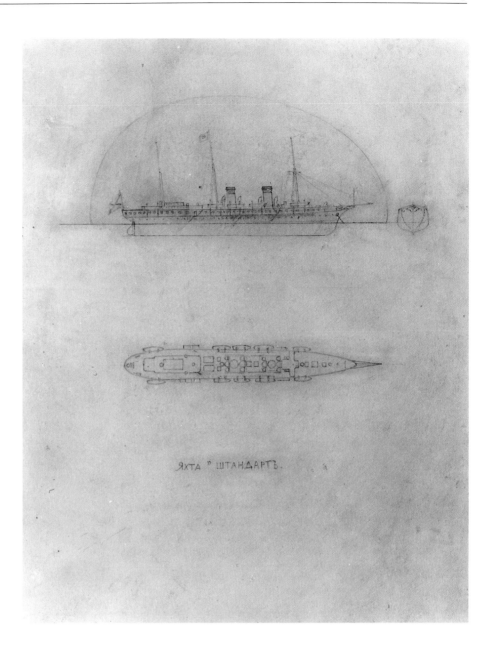

ЯХТА " ШТАНДАРТЪ.

Drawing for the model of the imperial yacht
Standart enclosed in the egg of that name
(plate 17), circa 1908. Pencil and watercolor
on paper, $6^3/_4$ x $5^1/_2''$ (17.2 x 14 cm).
Private collection

dred-and-fifty objects, was enriched by Queen Mary, the wife of George V,
who added two imperial eggs – the Colonnade Egg (plate 14; no. 26, p. 104)
and the Mosaic Egg (plate 23; no. 41, p. 112). The first comprehensive Fabergé
exhibition, which took place at the Victoria & Albert Museum in London in
1977, and the display of part of the royal collections at Buckingham Palace
in 1985/86, which was visited by hundreds of thousands, finally cemented the
jeweler's reputation in our time.

Fabergé was even more popular in the United States. In 1927 the Soviet
government put parts of the royal treasure and a great many imperial Easter
eggs up for sale in Berlin and London. The American businessman Armand
Hammer, who had been trading with the Soviet Union since 1921, acquired
thirteen eggs, including the so-called First Imperial Easter Egg of 1885 (no. 1,
p. 92), the Caucasus Egg of 1893 (plate 3; no. 8, p. 95), the Renaissance Egg
of 1894 (plate 4; no. 9, p. 96), the Danish Palace Egg of 1895 (plate 6; no. 11,
p. 97), the Egg with Revolving Miniatures of 1896 (no. 12, p. 97), the Pelican

Egg of 1897 (no. 13, p. 98), the Pansy Egg of 1899 (plate 11; no. 18, p. 100), the Swan Egg of 1906 (no. 28, p. 105), the Czarevitch Egg and Napoleonic Egg of 1912 (plate 21; nos. 36 and 37, pp. 109, 110), the Grisaille Egg of 1914 (no. 40, p. 111), and the Red Cross Egg with Resurrection Triptych of 1915 (plate 24; no. 43, p. 113). The English art dealer and owner of the Wartski Gallery in London, Emanuel Snowman, purchased the Blue Serpent Clock Egg of 1889 (no. 5, p. 94), the Coronation Egg of 1897 (plate 7; no. 14, p. 98), the Cuckoo Egg of 1900 (plate 12; no. 19, p. 101), and the Colonnade Egg of 1905 (plate 14; no. 26, p. 104). In the 1930s Hammer opened his Hammer Galleries of Imperial Russian Treasures in New York, where he sold his collection of Russian art, especially Fabergé objects, to American collectors.[6] One of these was Marjorie M. Post, who acquired, among other objects, two imperial eggs – the Silver Anniversary Egg of 1892 (no. 7, p. 95) and the Grisaille Egg – which can now be seen at the Hillwood Museum in Washington, D.C. Matilda Geddings Gray purchased the Napoleonic Egg, the Caucasus Egg, and the Danish Palace Egg from Hammer; these are now in the Museum of Art in New Orleans. The Virginia Museum of Fine Arts holds in trust the Lillian T. Pratt collection, which includes no less than five imperial eggs that, with the exception of the Peter the Great Egg of 1903 (no. 23, p. 103), once belonged to Hammer (nos. 12, 13, 37, 42, pp. 97, 98, 110, 112). As a matter of principle, no objects from the Pratt collection are loaned for exhibition purposes.

Today, Malcolm Forbes is the most important collector of Fabergé objects. His is the second largest private collection of works by Fabergé, after that of the British Queen. It contains eleven imperial eggs, one more than the State Museums of the Moscow Kremlin, and can be admired in its own small museum in New York. Together with Peter Schaffer, who regularly traveled to Russia at an early date in order to buy Fabergé objects and eventually opened his business "A la Vieille Russie" in New York, Forbes, Hammer, and the other collectors mentioned above are responsible for the extraordinary popularity of Fabergé in the United States. Forbes has loaned his objects to numerous exhibitions, notably to that in Munich and to that held in 1987 at the Villa Favorita in Lugano (Thyssen Collection). Since 1949 four Fabergé exhibitions have been shown at "A la Vieille Russie."

The fascination with Fabergé's art that had always existed among the royal dynasties of Europe began to be felt in the United States in the 1930s and in Central Europe in the early 1980s. The prices paid for Fabergé objects on the art market changed accordingly. These treasures, which were created for a specific group of buyers – the aristocracy, bankers, and the *nouveaux riches* – were extremely expensive during the heyday of the Fabergé workshop.[7] While small articles for daily use and hardstone animals cost "only" about 25 rubles, the czar had to pay an average of 30,000 rubles for the annual imperial Easter egg and as much as 250,000 rubles for a pearl necklace. Following World War I, interest in the art of Fabergé temporarily waned, and the prices for objects made by the firm dropped dramatically as large quantities were put up for sale by an impoverished aristocracy. The small stone animals could be acquired for one pound sterling, and Queen Mary of Great Britain was able to purchase the Colonnade Egg for only five hundred pounds in 1929. If an imperial egg were to appear on the market today, it

6. Solodkoff et al., 1984, p. 107 ff.
7. Habsburg, 1986, p. 104.
8. Ibid., p. 94.

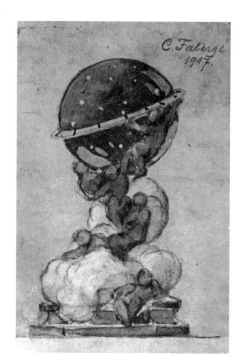

Peter Carl Fabergé, Design for an Easter egg
in the form of a clock, 1917. The egg was
never made

would undoubtedly fetch several million dollars. However, the chances of this happening are very slight. Eight of the fifty-six imperial eggs created by workmasters Michael Perchin (up to 1904) and Henrik Wigström have disappeared. Of the forty-eight eggs still known to be in existence, eleven are in the Forbes Collection, ten in the State Museums of the Moscow Kremlin, seventeen in American, and eight in European collections. The owners of the two remaining eggs are unknown.

Between 1885 and 1894 Czar Alexander III presented his wife with ten Easter eggs, and Nicholas II, from his father's death in 1894 to 1917, presented the Dowager Czarina and his wife with forty-six Easter eggs. Geza von Habsburg has proven that these figures are incomplete.[8] According to a recently discovered list, Alexander III actually ordered fifteen Easter eggs from Fabergé, five of which – among them, the Egg with Blue Enamel Ribbing of 1885-91 (plate 1; no. 2, p. 92) and the Resurrection Egg of 1886 (no. 3, p. 93) – were probably presented to the czarevitch.

How did Carl Fabergé and his master craftsmen come to create such a profusion of exceptional inventions, which, though they sometimes almost offend good taste, are among the most exquisite and technically accomplished examples of the art of the ornamental Easter egg? What models were used, where did inspiration come from, at what point did personal invention begin? Gustave Fabergé, Carl's father, had lived with his family in Dresden since 1860. There Carl completed a business course at the trade school and must certainly have visited the outstanding Wettin collections, especially the Green Vaults on the ground floor of the royal palace – perhaps the most important, indubitably the most stylistically uniform treasury in Europe. It consisted for the most part of items that had been collected by August the Strong, Elector of Saxony and King of Poland, who had not only had large funds at his disposal (the Wettins, at that time, were considered to be among the richest princes in Germany) but also excellent taste. The fruitful relationship between like-minded individuals that prevailed in dealings between the czar and Fabergé (that is, between patron and artist) must also have existed between August the Strong and Johann Melchior Dinglinger, the finest German goldsmith of the early eighteenth century. The Green Vaults contain numerous treasures by Dinglinger that he designed and produced for his master. In particular, the small enameled, toylike figures studded with precious stones, which lack only a mechanism for movement, must have influenced Fabergé's design of the surprise that is revealed, moving or singing, when each imperial Easter egg is opened. In addition, the concept of Fabergé's Renaissance Egg (plate 4; no. 9, p. 96), made by Michael Perchin in 1894 as a present for Czarina Marie Feodorovna, was certainly inspired by an egg-shaped casket in the Green Vaults that had been created around 1700 by Le Roy in Amsterdam.

The so-called First Imperial Egg of 1885 (no. 1, p. 92) is an almost exact replica of an eighteenth-century royal Easter egg that is now in Rosenborg Castle in Copenhagen. Both consist of an ivory eggshell containing an enameled gold hen, with rubies as eyes, which opens to reveal a golden crown studded with pearls which, in turn, encloses a gold ring. The copy may have been made because Czarina Marie Feodorovna was descended from the Danish royal dynasty or because Perchin had seen the original in Copenhagen.

However, this is of little immediate importance, since other eggs of this type exist: the Kunsthistorisches Museum in Vienna possesses a similar, eighteenth-century "surprise egg" and a further example of the type, dating from the nineteenth century and also Viennese in origin, is in the Forbes Collection.

Besides Vienna and Florence, Fabergé also visited Paris, where he was able to study the works and outstanding technical skills of French jewelers of the eighteenth century. The Louis XV and Louis XVI styles became the determining influence on his work, while the knowledge that both these kings were in the habit of giving ornate Easter eggs as presents probably had a considerable effect on his later creations. The Azova Egg of 1891 (plate 2; no. 6, p. 94), for instance, created by Perchin for Alexander III, is modeled on French work: an egg-shaped *bonbonnière* in the treasury of the Hermitage in Leningrad may serve as a comparison.[9] However, the surprise in the Azova Egg is wholly modern – a miniature replica of the *Pamiat Azova* cruiser, in gold and platinum with ruby hatches, floating on an aquamarine sea. Czarevitch Nicholas, the future Czar Nicholas II, had sailed around the world on this cruiser in 1890/91.

The Peacock Egg (no. 30, p. 106), created in 1908 by Henrik Wigström as a present for the Dowager Czarina, was obviously inspired by an eighteenth-century peacock automaton by James Cox in the Hermitage. The enameled gold peacock carefully puts one foot in front of the other, moves its head, and spreads its impressive tail. The Fabergé craftsman Dorofeev is said to have worked on this complicated mechanism for almost three years.[10]

The Peter the Great Egg (no. 23, p. 103), crafted by Perchin in 1903, was modeled on a mid-eighteenth century toilette case owned by Czarina Elisabeth Petrovna and now on display in the treasury of the Hermitage in Leningrad.[11] This Easter egg opens to reveal a replica of Etienne-Maurice Falconet's famous monument to Peter the Great in Leningrad.

The Swan Egg (no. 28, p. 105), fashioned in 1906 for Czarina Alexandra, was obviously influenced by the swan automaton by James Cox that was exhibited at the Paris World Exposition in 1867.[12] The list of Fabergé creations that were imitations of, or at least inspired by, objects of earlier periods could be continued almost indefinitely. The similarity of the Blue Serpent Clock Egg of 1889 (no. 5, p. 94) to neoclassical shelf clocks of the late eighteenth century must serve as a final example.[13]

However, in contrast to other goldsmiths of his time, Fabergé did not create copies so perfect that even experts would later mistake them for originals from the Middle Ages or the Renaissance. Even in the later imperial eggs, he impressed his individual style on the works created by his firm: the models of earlier eras were transformed into objects in the "Style Fabergé."

The art nouveau movement, which began to replace historicism in France in the early 1890s, reached Germany a few years later and subsequently spread to almost all European countries, but it was of virtually no significance in Russia – or, at least, its impact there has not yet been studied adequately. Some objects by Fabergé – among them, cigarette cases and pieces of jewelry – belong incontestably to art nouveau.[14] Yet whereas such designers of art nouveau jewelry as René Lalique and Georges Fouquet worked exclusively in the new style from the beginning of the 1890s, Fabergé essentially remained true to historicism or, rather, to himself, to his individual style.

9. Ibid., cat. no. 652.
10. Solodkoff et al., 1984, p. 69.
11. Ibid., p. 61.
12. Ibid., p. 61.
13. Ibid., p. 61.
14. Habsburg, 1986, cat. nos. 47-48, 50, 131-33, 164.
15. Solodkoff et al., 1984, illustrated on p. 85.
16. Habsburg, 1986, p. 97.
17. Solodkoff et al., 1984, p. 78. The Easter egg referred to is perhaps the Grisaille Egg in the Hillwood Museum, Washington, D.C. (no. 40, p. 111). It was modeled on an eighteenth-century automaton in the Hermitage, Leningrad.

Nonetheless, it is precisely his most precious works, the imperial Easter eggs, that occasionally display features reminiscent of art nouveau. They occur wherever ornamental plant motifs are used or flower tendrils cover an enameled surface. Representative of this style is the Lilies of the Valley Egg of 1898 (plate 8; no. 15, p. 99), which is covered with lilies of the valley made from pearls and diamonds and is supported by legs consisting of ornamental flower stems and leaves. However, the surprise in this Easter egg, which was presented by Nicholas II to his mother, consists of three portrait miniatures of the czar and his eldest daughters, Grand Duchesses Olga and Tatiana, in a style that recalls the eighteenth century. The Pansy Egg of 1899 (plate 11; no. 18, p. 100) also features flowers studded with diamonds sprouting from ornamental legs in the shape of plants, and here, too, the surprise is eighteenth-century in style – an easel bearing a heart-shaped shield to which a great number of portrait miniatures are attached. A further instance of art nouveau· influence is provided by the Clover Egg of 1902 (no. 22, p. 102),[15] which also has flowers and leaves sprouting from plantlike ornamental legs.

In 1911, when art nouveau was already drawing to a close in Europe, the Fabergé workshop produced the Orange Tree Egg (plate 20; no. 35, p. 109), a piece belonging almost entirely to this style. Although the gold tree trunk is rooted in a rectangular enamel flowerpot in the Louis XVI style, its carved nephrite leaves, together with its blossoms and ripening fruits made of precious stones, are pure art nouveau. When a particular orange is pressed, a lid opens at the top of the tree and a tiny bird emerges singing. As von Habsburg has pointed out, this egg may have been modeled on the cupola of the exhibition building of the Secession movement in Vienna, designed by Joseph Maria Olbrich in 1897/98.[16]

These few examples demonstrate that, although art nouveau elements are discernible in some Fabergé objects, including the imperial eggs, it would be incorrect to reckon Fabergé among the chief exponents of this style. His taste as an artist was shaped and influenced by the French *dixhuitième*, and he revived the style of this period with the greatest refinement at the end of the feudal era, before the demise of most European monarchies. Yet Fabergé was not simply an imitator. In many cases, he goes beyond his models, even perfects them, by transforming them in terms of his individual style. In this respect, he must be seen as a genius. He was recognized as such by the Russian imperial family, as is revealed by a letter from the Dowager Czarina Marie Feodorovna to her sister, Queen Alexandra of England. Dated April 8, 1914, and written in Danish, it tells of an Easter egg presented to her by Nicholas II, which contained a miniature sedan-chair automaton carried by two Moors and occupied by a figurine of Czarina Catherine the Great: "... you wind it up and the Moors start to walk – it is an incredibly beautiful and outstanding masterpiece. Fabergé is the greatest genius of our time. I told him so. I said: 'vous êtes un genie incomparable.'"[17]

Christopher Forbes Fabergé: The Firm and the Family

Malcolm Forbes first brought home a copy of A. Kenneth Snowman's *The Art of Carl Fabergé* when I, his number three son, was ten. Hours thereafter were spent in endless fascination, poring over the hundreds of illustrations, especially the color plates depicting the dazzling fantasy Easter eggs created for the last two czarinas.

The book was followed by purchases of a few pieces of Fabergé – a gold presentation cigarette case, a Red Cross egg charm, and other odds and ends for my mother. By 1965, however, my father had decided to stop dabbling and determined that *Forbes Magazine* should have an important collection of Fabergé. In the ensuing years, as the collection has grown, it has been a source of amusement for me, when lecturing, to point out the parallels between Fabergé and Forbes.

Both names, of course, begin with an "F." Both family names are also the company name. Both companies' names appear on their respective "products" which, in turn, for their creation and marketing, require(d) the talents of, and provide(d) employment for, several hundred people. Both firms enjoy(ed) a rich and powerful domestic clientele as well as an international reputation. And, most importantly of all, at least in the eyes of this author, at Fabergé et Cie and Forbes, Inc., nepotism is (was) not preached, it is (was) practiced! Furthermore, both firms owe their fame, if not their founding, to the second generation. Like their four sons, both Peter Carl Fabergé and Malcolm Stevenson Forbes owe(d) their jobs to their fathers.

Peter Carl Fabergé was born in St. Petersburg (now Leningrad) on May 30, 1846. Four years earlier, his father, Gustav Fabergé, had established a jewelry business under his own name at Number 12 Bolshaya Morskaya Street (now Herzen Street). The founding Fabergé earned the title "Master Goldsmith" in 1841, after serving an apprenticeship with goldsmith Andreas Ferdinand Spiegel and goldsmith and jeweler Johann Wilhelm Keibel.

Gustav Fabergé was born in 1814 in Pernau on the Baltic, whence his father Peter had emigrated from Schwedt-on-the-Oder (northeast of Berlin) at the turn of the century. The family originally were Protestants (Huguenots) from the Picardy region, who fled France when Louis XIV terminated religious tolerance by revoking the Edict of Nantes in 1685.

In 1842, Gustav Fabergé not only started his firm but his family as well, marrying Charlotte Jungstedt, daughter of a Danish painter. His business prospered. In 1857, August Wilhelm Holmström was appointed head jeweler (his son would succeed him after his death in 1903 – nepotism was not confined to the owner's family at Fabergé!). Gustav Fabergé sent his son to a private school, the German-speaking St. Anne's, and by 1860 he could afford to take "early retirement." Leaving the business to be run by two associates,

◁ Orange Tree Egg, 1911. Detail.
(See plate 20)

Hiskias Pendin and V. A. Zaianchovski, he moved to Dresden, where a second son, Agathon, was born in 1862.

The oldest son, Peter Carl, continued his education at the Dresden Handelsschule and, after a Continental tour, served an apprenticeship under a Frankfurt jeweler, Josef Friedman. His talents must have been impressive – in 1870, aged twenty-four, he was deemed ready to return to St. Petersburg to take over his father's firm. Two years later, he married Augusta Julia Jacobs, daughter of an overseer at the Imperial Furniture Workshop.

Not for another ten years, however, did Peter Carl Fabergé and the family firm come into their own. His father's faithful manager, Hiskias Pendin, died in 1881, as did Czar Alexander II. The following year, Fabergé moved the operation to larger quarters at Numbers 16/17 Bolshaya Morskaya Street and his twenty-year-old brother, Agathon, joined the company.

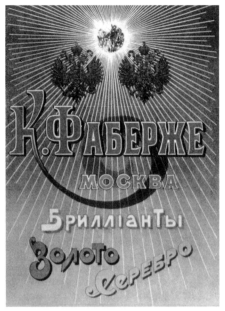

With the younger generation firmly in control of the firm and the nation, the house of Fabergé won a gold medal at the Pan-Russian Exhibition in Moscow and attracted the attention of the new czar, Alexander III, and his wife, Czarina Marie Feodorovna, the former Princess Dagmar of Denmark. Imperial patronage and the coveted awarding of the warrant as "Jeweler of His Majesty and the Imperial Hermitage" soon followed.

Cover of the sales catalogue issued by Fabergé's Moscow branch in 1899

1885 was a milestone year. The firm's reputation was established internationally by the awarding of a Gold Medal at the Nuremburg Fine Art Exhibition for chief workmaster Eric Kollin's replicas of the recently discovered Scythian Treasure. More relevant to the present exhibition, a naturalistically enameled gold egg, containing a gold yolk in which was concealed a tiny chased varicolored gold hen (which, in turn, was originally the hiding place of a miniature imperial crown and ruby egg charm), was created for the young czar to present to his consort on Easter. An annual tradition had been initiated and a revolution in taste and fashion effected. Peter Carl Fabergé, with imperial encouragement, substituted creativity and craftsmanship for craving of carat content, wit and workmanship for worship of weight of precious metals and minerals.

Twenty-six-year-old Michael Perchin, a native of Petrozavodsk, Karelia, succeeded Kollin as chief workmaster in 1886, and thereafter his stamped initials mark all the surprise eggs by the house of Fabergé for Czar Alexander III as well as those made for Nicholas II through 1903.

Fabergé's Moscow branch

Elaborately decorated eggs were a custom and a craft of long standing in Russia. Well before Fabergé began working for the imperial family, eggs of precious materials had been created for previous czars, including, a generation earlier, a silver-gilt surprise egg by Nordberg for Alexander II. Fabergé and his team of designers, goldsmiths, jewelers, enamelers, lapidaries, and miniaturists, under the direction of Perchin and, later, Henrik Wigström, succeeded in bringing this form to unparalleled and unprecedented levels of refinement, artistry, and imagination.

Early eggs were quite small (the Spring Flowers Egg [plate 9; no. 16, p. 99] is only $3^1/4$ inches high). They became progressively larger through the balance of Perchin's career, culminating in the monumental (relatively speaking!) $14^1/2$-inch-tall Kremlin Egg of 1903. Under Wigström, who succeeded Perchin that year, this trend was reversed, and the surviving eggs produced and delivered through 1916 measure between $3^1/6$ and $11^1/4$ inches.

Fabergé's Moscow branch

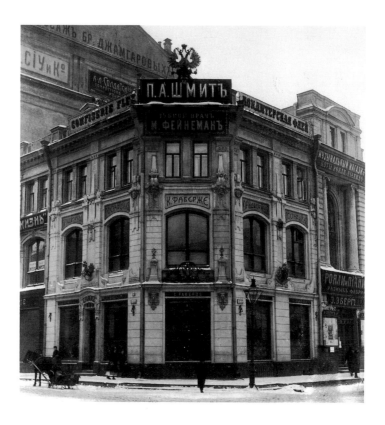

The eggs were a surprise not only for the czarina but for the commissioning sovereign as well. "Your Majesty will be content," is the reply traditionally attributed to Fabergé in response to the czar's query regarding the subject of the egg for that year.

The surprises most frequently favored were painted miniatures of members of the imperial family, or places and events associated with them. Perhaps the most personal achievement of this genre is the Fifteenth Anniversary Egg of 1911 (plate 19; no. 34, p. 108). This quintessential Fabergé masterpiece is both a family album of Czar Nicholas II and a diary of his reign – it is also the favorite piece of both my father and myself. Other *tours de force* with miniatures included in the exhibition are, in chronological order: the Caucasus Egg of 1893, the Danish Palace Egg of 1895, the Lilies of the Valley Egg of 1898, the Pansy Egg of 1899, the Alexander Palace Egg of 1908, the Napoleonic Egg of 1912, the Romanov Tercentenary Egg of 1913, the Mosaic Egg with miniature in sepia grisaille of 1914, the Red Cross Egg with Resurrection Triptych of 1915, and the Cross of St. George Egg of 1916 (plates 3, 6, 8, 11, 16, 21-24, 26; nos. 8, 11, 15, 18, 31, 36, 39, 41, 43, 45, pp. 95, 97, 99, 100, 107, 109, 111-14).

The Red Cross Egg with Resurrection Triptych (plate 24) is one of the only two eggs that make direct reference to the *raison d'être* of Easter. Thus, in spite of the profound faith of the last czarina, family and current events in her adopted homeland took precedence in these souvenirs of the most holy of holy days.

In addition to painted miniatures, exquisitely wrought three-dimensional miniature replicas in precious metals were also popular surprises. The Coronation Egg of 1897 (plate 7; no. 14, p. 98) opens to reveal a perfectly articulated lilliputian carriage with working doors and folding steps, with the plush

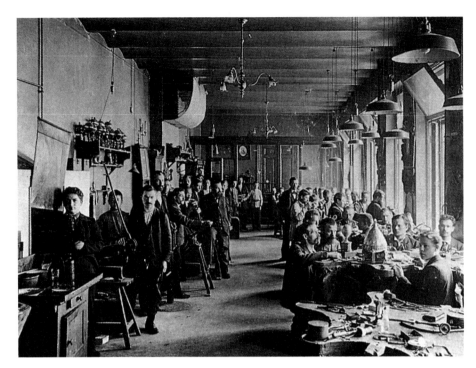

Two views of Michael Perchin's workshop in St. Petersburg, circa 1903. Henrik Wigström and Michael Perchin (bearded) are on the left; the Chanticleer Egg (no. 47, p. 115) can be seen on the workbench

rendered in strawberry-red enamel and the windows in engraved rock crystal. In addition to this, other gold miniatures include tiny replicas of the cruiser *Pamiat Azova*, of Alexander Palace, the imperial yacht *Standart,* and the monumental equestrian statue of Czar Alexander III (plates 2, 16-18; nos. 6, 31-33, pp. 94, 107, 108).

The turn of the century witnessed the advent of automation within Fabergé's wonderful eggs. The minuscule replica of the imperial train, with its clockwork mechanized locomotive, is unparalleled (plate 13; no. 20, p. 101). Cuckoo birds, chanticleers, swans, peacocks, and elephants are among the menagerie to be found strutting and singing in other eggs (included here are the Cuckoo Egg of 1900 [plate 12; no. 19, p. 101] and the Orange Tree Egg of 1911 [plate 20; no. 35, p. 109]).

A number of eggs have been separated from their surprises. The most famous of these is the Renaissance Egg of 1894 (plate 4; no. 9, p. 96), a pastiche of the Le Roy casket now in the Green Vaults in Dresden. With this and a number of other eggs, fantasy and imagination must fill the void.

Given these annual demonstrations of brilliance, it is not surprising that Fabergé's reputation spread internationally – in part through "word of mouth" within the imperial family and their far-flung relations (for example, one of Czarina Marie Feodorovna's sisters was Queen Alexandra of Great Britain, one brother King Frederick VIII of Denmark and another King George I of Greece). Foreign expositions also assured Fabergé's acclaim outside Russia. In 1888 the firm was awarded a special diploma at the Nordic Exhibition in Copenhagen. When that exhibition was held nine years later in Stockholm, Fabergé was awarded a Royal Warrant of the Court of Sweden and Norway. At the 1900 World Exposition in Paris, a display including some of the fabled imperial Easter eggs saw Fabergé acclaimed *Maître* by the Paris Guild of Goldsmiths and decorated with the *Legion d'Honneur* by the French government.

Fabergé's salesroom in St. Petersburg

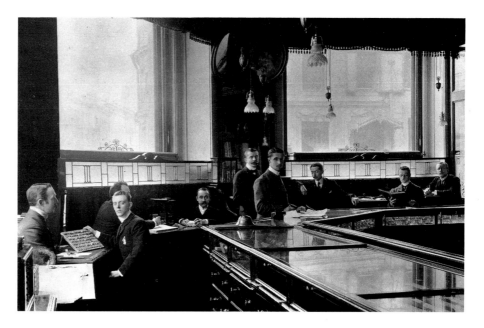

As far away as Bangkok and Baltimore, Fabergé was *à la mode*. Numerous commissions were received from King Chulalongkorn of Siam, and many of the resulting works remain in the collection of the Thai royal family. Concurrently, such American plutocrats as J. P. Morgan, Jr., and Henry Walters cruised up the Neva on their yachts and left laden with perfect presents from Bolshaya Morskaya Street. Walters, like Britain's Queen Mary, was a Fabergé consumer who turned collector and, like the queen, he ultimately acquired two of the Easter eggs made for the czarinas (nos. 21, 29, pp. 102, 106). These and other Fabergé purchases are on view in the Walters Art Gallery in Baltimore. Her Majesty the Queen's collection contains the 1905 Colonnade Egg, a miniature temple of love fashioned as a clock (plate 14; no. 26, p. 104), and the 1914 Mosaic Egg, a needlepoint-like web of precious stones which opens to reveal a pedestal frame with a miniature of the imperial children (plate 23; no. 41, p. 112).

The empire's booming economy created a burgeoning class of *nouveau riche* Russians. These industrialists and financiers, along with great landholders and some of the established aristocracy, created an enormous demand for Fabergé's *objets de luxe*. Imperial patronage bestowed cachet, but the cash, which fueled the need for three domestic branches outside of the main shop in St. Petersburg (Moscow, established in 1887, Odessa, in 1890, and Kiev, in 1905) and a catalogue operation, all of which provided work for over five hundred employees, was mostly newly made.

Not only did Peter Carl Fabergé's business expand, so did his family. Four sons were born before the delivery of the first imperial egg in 1885: Eugène (1874-1960), Agathon (1876-1951), Alexander (1877-1952), and Nicholas (1884-1939). Like Malcolm Forbes's four sons, all of Fabergé's sons entered the business established by their grandfather and enlarged and enriched by their father. Here, however, my brothers and I would be happy to see the plentiful parallels between Fabergés and Forbeses end – a dramatic change in regimes and philosophy of governance in Russia caused the house of Fabergé to be closed down in 1918. Peter Carl Fabergé died near Lausanne, Switzerland, on September 24, 1920.

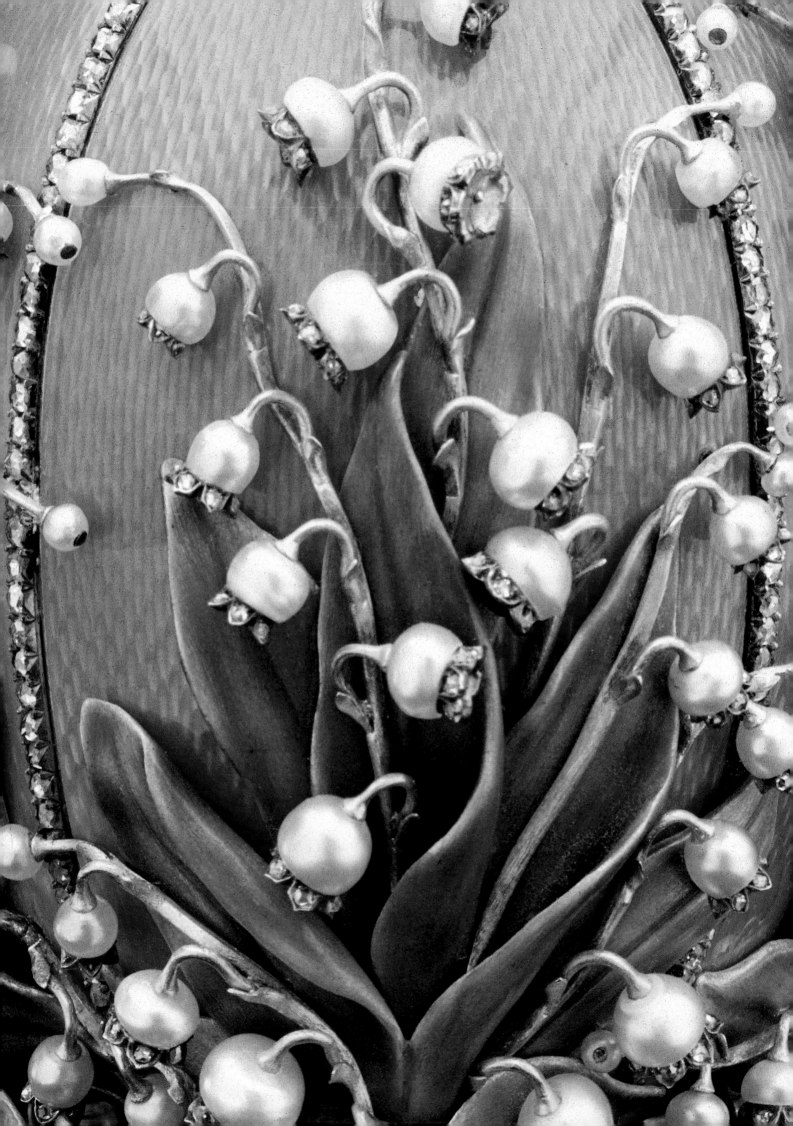

Irina Rodimtseva The Fabergé Collection
in the Armory Museum, Moscow

The Moscow Kremlin is a huge treasure-house of Russian and world art. Within its walls are located the Cathedral museums of the Assumption, the Archangel, and the Annunciation, the Church of the Deposition of the Virgin's Robe, and, in the Patriarch's Palace, the Museum of Seventeenth-Century Russian Art.

One of the oldest and most opulent Kremlin museums is the Armory Museum, which houses a major collection of applied and decorative art. Built up over many centuries, the collection today contains nearly ten thousand objects, documenting the achievements of craftsmen in Russia, both native and foreign, both within the Kremlin and outside it, from the twelfth to the twentieth century. Only a few jewelry firms active in the nineteenth and twentieth centuries are represented in the Armory Museum. For a long time, pieces from this period were not collected by the Kremlin museums because specialists regarded them as too eclectic to be ranked as genuine works of art. Indeed, such objects were sold abroad in the 1930s, and Russian jewelry now graces many Western collections as a result. Even the exquisite creations of the Fabergé firm were not exempted from this severe judgment. In fact, although admired throughout the world for its charm and unsurpassed craftsmanship, it was not until recently that the work of Fabergé and his colleagues was accorded due recognition in its homeland.

The Fabergé firm triumphed at the Paris World Exposition of 1900, where it exhibited miniature replicas of the czar's crown, scepter, and orb, as well as some of the famous surprise imperial eggs. Peter Carl Fabergé won the highest award, the *Grand Prix,* and was decorated with the *Legion d'Honneur.* On the same occasion, Michael Perchin, creator of many surprise and fantasy objects for the Fabergé firm, received a medal that was donated to the Armory Museum in 1974 by the craftsman's great grandson, Georgi Aristov (plate 29).

The house of Fabergé has been widely acclaimed for its use of precious stones and their imaginative combination with other materials. Fabergé himself possessed a famous mineral collection, and dealers in fine gems were always welcome guests in his home. Indeed, in the variety and quality of the precious stones he employed, Fabergé surpassed even the most renowned firms. With consummate skill, his craftsmen utilized rock crystal, nephrite, jade, heliotrope, topaz, various shades of chalcedony, every possible type of jasper and agate, obsidian, lapis lazuli, and rhodonite, as well as the finest diamonds, sapphires, rubies, emeralds, and pearls.

Fabergé also manufactured small carved stone sculptures, initially from materials purchased from stonecutters of the Ural region and from the lapidary factory in Peterhof. Later, when the firm had established its own stone-

◁ Lilies of the Valley Egg, 1898. Detail. (See plate 8)

cutting shop in St. Petersburg, it began producing miniature sculptures of people, animals, and flowers from precious and semiprecious stones. These highly original, exceptionally lifelike pieces are now housed in the Armory Museum.

Seals, serving both a practical and a decorative function, constituted another important part of the firm's stone carving activities. One of the seals included here (plate 33), made from silver and with an egg-shaped purpurine handle, bears the name of the imperial yacht *Standart,* the same vessel that is reproduced in the imperial egg of that name (plate 17; no. 32, p. 107). Other notable Fabergé seals in the Armory Museum are that created in golden topaz by Wilhelm Reimer for Grand Duke Sergei Alexandrovich, governor of Moscow from 1857 to 1905, in which the Moscow coat of arms and the names of the local estates Ilinskoe and Usovo are engraved in the stone (plate 31), and that crafted by Henrik Wigström from carnelian, with a gold setting and figured nephrite handle and bearing the secondary Russian state emblem (plate 32).

The Fabergé firm was instrumental in reviving such techniques as the use of translucent colored enamel on a guilloché background and the tinting of gold and other metals. The guilloché method of enameling cannot be imitated, even utilizing the most modern equipment. The Fabergé craftsmen employed the technique of applying translucent enamel to an engraved background to new and dazzling effect. They used a total of one hundred and twenty-four different tints and shades, each of which could give rise to a new decorative effect in conjunction with the patterns engraved into the guilloché background. The same color applied to different patterns was capable of producing a number of shades. Common motifs of the highly varied patterns were fir tree shapes, vertical, horizontal, undulating, zigzag, or crisscrossing lines.

Commentators on Fabergé's work have emphasized his exceptional skill as an organizer. In several branches – in Moscow from 1887, in Odessa from 1890, in London from 1903, and in Kiev from 1905 – some five hundred craftsmen of varying specialties worked under Fabergé's supervision to produce truly unique objects of the highest possible quality. Each craftsman, whether painter, designer, goldsmith, caster, chaser, enameler, stonecutter, or maker of mechanized surprises, could express his individuality to the full and thereby enrich the final product. Present-day artists are astonished by the high technical and artistic standards of the firm's work, including the pieces manufactured for less wealthy clients and even the mass-produced items.

The series of imperial Easter eggs represents a rare combination of artistic inspiration and technical perfection. Commissioned by members of the imperial family, the eggs surpassed the firm's other products in splendor, inventiveness, and execution. All pride of workmanship was concentrated in these eggs. Each contained a novel surprise that never failed to produce the desired reaction in the recipient.

It should be noted that, in addition to his concern to achieve the highest level of workmanship, Fabergé was also sensitive to changes in taste and style and did not hesitate to embrace the latest trends in the art world. Thus, contemporary developments in the visual arts can be traced in the eggs: some are in traditional Russian styles, others in classical and rococo modes, and still others, from the early 1890s on, reflect the influence of art nouveau.

View of the Fabergé exhibition held in March 1902 in the palace of Grand Duke Vladimir, St. Petersburg, in aid of the Society of Patriotic Ladies. Imperial Easter eggs are displayed in the showcases. From: *Niva*, no. 12 (1902), p. 233

Yet in each case, the perfect execution guaranteed a work of indisputable originality.

An array of first-class craftsmen, each famous in his own right, worked under Fabergé's direction. One of the most talented was Michael Perchin, the creator of many exquisite objects that graced the homes of the czar and other prominent clients. The first imperial Easter eggs are stamped with his initials and mark the beginning of a tradition that continued until 1916.

The earliest imperial egg in the Armory Museum collection is the Azova Egg of 1891 (plate 2; no. 6, p. 94). Made by Perchin and his Estonian assistant, Yuri Nicolai, it contains a replica of the cruiser *Pamiat Azova,* mounted on an aquamarine base and depicting the ship in every detail. The model sits in an egg made of red-tinged heliotrope and decorated with diamond-studded rococo scrolls.

The Madonna Lily Egg (plate 10; no. 17, p. 100) is notable for the elegant lightness of its sun-gold tones. In this piece, with its egg-shaped clock, Perchin used his favorite technique of combining matte and polished gold to achieve a distinctive play of light that is characteristic of his work. Perchin also had a penchant for varicolored gold, which he produced by mixing gold with other metals. Crowning the Madonna Lily Egg is a delicate bouquet of onyx lilies, from which small diamond pistils emerge. The composition of the whole emphasizes proportion and harmony. The egg is divided by twelve vertical stripes studded with diamonds and rests on an elegant stand with a rectangular base. The graceful scrolls on the sides of the egg are echoed in the cast support and in the chasing on the base.

A particularly extravagant egg created by Perchin caused a sensation at the Paris World Exposition of 1900. It commemorated an event very important to

the Russian state – the completion of the Trans-Siberian Railway (plate 13; no. 20, p. 101). A map of the route is engraved on the silver central section of the egg. The surprise inside, a model of the first Siberian train, consists of a fully operational platinum locomotive and five gold coaches.

Perchin died in 1903, aged forty-three and at the peak of his career. Supervision of Perchin's shop passed to his assistant, Henrik Wigström, who continued the tradition of superb craftsmanship and imaginative design.

In 1908 the firm created a nephrite egg containing a replica of Alexander Palace at Czarskoe Selo (plate 16; no. 31, p. 107). The egg was decorated with miniature portraits of Czar Nicholas II's five children, finely executed in watercolor on ivory. Garlands and wreaths with diamond and ruby set bows are encrusted between each portrait.

Another egg adorned with portraits was produced in 1913 to mark the tercentenary of the Romanov dynasty (plate 22; no. 39, p. 111). A well-known painter of miniatures, Vassily Zuiev, depicted all representatives of the dynasty from Michael to Nicholas II. The portraits are surrounded by double-headed eagles and emblems of the czar's authority on a background of white enamel. The shaft, crafted by S. P. Petuchov of the St. Petersburg glass factory in the form of the coat of arms of Old Russia, is made from purpurine, a material whose method of manufacture is no longer known.

The Armory Museum collection contains two eggs made from rock crystal. The first consists of a perfectly clear crystal egg that contains a precisely detailed model of the imperial yacht *Standart* (plate 17; no. 32, p. 107). An eagle carved from lapis lazuli is perched on either side of the egg; a pear-shaped pearl pendant hangs from each of them. Two lapis lazuli dolphins with intertwined tails form the shaft.

The second egg made from rock crystal contains a replica of Peter Trubetskoy's monument to Alexander III (plate 18; no. 33, p. 108). The design of the egg betrays great sensitivity to materials. The rock crystal is finely engraved with laurel leaves, while the delicate platinum lacework, studded with diamonds and bearing a tasseled fringe, lends the piece a distinctive charm. Dull, steel-gray platinum, also used for the double-headed eagles on the sides of the egg and for the cherubs supporting the monument, is a difficult material to work with. Here, it combines with the radiance of diamonds and the transparency of rock crystal to produce a work of singular refinement.

The latest surprise egg in the Armory Museum collection is dedicated to the hard years of World War I, whose tragic events are reflected in the austere design (plate 25; no. 44, p. 113). The brightly polished steel egg is supported by four artillery shells; a sleek nephrite base accords with the simplicity of the whole. Despite the difficult times, the firm maintained its high standards of workmanship, noticeable here especially in the gold details, and did not sacrifice elegance of design, as is indicated by the surprise inside the egg – a miniature steel easel bearing the monogram of Czarina Alexandra Feodorovna.

The superb craftsmanship of Fabergé work, often using processes known only to the firm, and its inexhaustible formal inventiveness represent a level of artistic and technical originality that made the house of Fabergé a leading force among both Russian and Western jewelry firms of the time. The standards set by the firm continue to compel admiration to this day.

Chronology of the House of Fabergé

Peter Carl Fabergé's parents, Gustav and
Charlotte Fabergé. Dresden, circa 1880

1814 Gustav Fabergé, of French Huguenot origin, is born at Pernau, Estonia.

1842 Gustav Fabergé establishes the jewelry firm on Bolskaya Morskaya Street, St. Petersburg.

1870 Peter Carl Fabergé, Gustav's son, assumes management of the firm at the age of twenty-four. He is apprenticed to a workmaster and travels in Europe to study art and economics.

1872 Peter Carl Fabergé marries Augusta Julia Jacobs. They have four sons: Eugène (1874-1960), Agathon (1876-1951), Alexander (1877-1952), and Nicholas (1884-1939). All join the Fabergé firm.

1882 Agathon (1862-1895), Peter Carl's younger brother, born and educated in Dresden, joins the firm.
Fabergé is awarded a Gold Medal at the Pan-Russian Exhibition, Moscow.
Shop moves to 16 Bolshaya Morskaya Street.

1885 The first imperial Easter egg is presented to the Czarina by Alexander III. The Czar grants Royal Warrants to the house of Fabergé.
The firm receives a Gold Medal at the Nuremberg Fine Art Exhibition for their replicas of the Scythian Gold Treasure in the Hermitage.

1886 Michael Perchin, maker of many of the imperial Easter eggs, joins the firm and becomes head workmaster.

1887 Establishment of the Moscow branch.

1890 St. Petersburg quarters enlarged.
Branch opens in Odessa.

1894 Eugene Fabergé, Carl's oldest son, joins the firm.
Death of Czar Alexander III.

A room in Peter Carl Fabergé's house
in St. Petersburg

Peter Carl Fabergé's house in St. Petersburg,
circa 1900

Fabergé's salesroom in Moscow

Augusta Fabergé, the goldsmith's wife

Peter Carl Fabergé, circa 1918

1896 Coronation of Czar Nicholas II.
 The kokoshnik mark probably adopted in this year as the Russian mark for gold and silver.

1897 The firm is awarded a Royal Warrant by the courts of Sweden and Norway.

1898 Four-story building acquired for a million rubles at 24 Morskaya Street, St. Petersburg.

1900 Three imperial Easter eggs shown for the first time abroad at the Paris World Exhibition.
 Peter Carl Fabergé acclaimed *Maitre* and decorated with the *Legion d'Honneur*. Firm opens at 24 Morskaya Street.

1903 Establishment of the London branch at Berners Hotel under the management of Arthur Bowe.
 Death of Michael Perchin, whose workshop is taken over by Henrik Wigström.

Peter Carl Fabergé at Pully, near Lausanne, July 1920

1904 Fabergé invited to visit King Chulalongkorn of Siam.
 First exhibition of works by Fabergé in England, at the Albert Hall, London.

1905 Kiev branch established.

1906 London branch moves to 48 Dover Street under the management of Nicholas Fabergé, Peter Carl's youngest son, and H. C. Bainbridge.

1910 Kiev branch closes.

1911 London branch moves to 173 New Bond Street.

1913 Romanov Tercentenary.

1915 London branch closes.

1917 The Russian Revolution begins in Petrograd.
 Firm is taken over by a committee of employees.

1918 Firm closed by the Bolsheviks.
 Peter Carl Fabergé escapes from Russia as a Foreign Embassy courier.

1920 Peter Carl Fabergé settles in Lausanne, Switzerland, where he dies on September 24.

1929 Eugene Fabergé brings his father's ashes to Cannes, France, where they are buried in the grave of Madame Fabergé, who had died in 1925.

PLATES

1 Egg with Blue Enamel Ribbing

St. Petersburg, 1885-91

WORKMASTER: Michael Perchin

MARKS: M.P, 56, crossed anchors and scepter, 44 255

MATERIALS/DIMENSIONS: Egg: Green, red, and yellow gold, sapphire blue enamel, sapphires, diamonds. Height 4³/₈″ (11 cm). Rabbit: Agate, rubies

TECHNIQUE: Gold openwork over engine-turned enamel

Private collection

DESCRIPTION: Imperial Easter egg by Peter Carl Fabergé, in three colors of gold and translucent sapphire blue enamel, surmounted by an imperial crown set with sapphires and diamonds, opening to reveal an agate figure of a rabbit set with ruby eyes.

PROVENANCE: Formerly supposed to have been a gift presented by Czar Alexander III to his wife, Czarina Marie Feodorovna, between 1885 and 1890, but more likely to have been a present to the czarevitch between 1890 and 1894.

REFERENCES: New York, 1951, no. 157; Snowman, 1964, pp. 80-81, 319 (ill.); Habsburg and Solodkoff, 1979, pp. 157, no. 3, 159 (ill.); Solodkoff et al., 1984, p. 60; Munich, 1986-87, p. 267, no. 533.

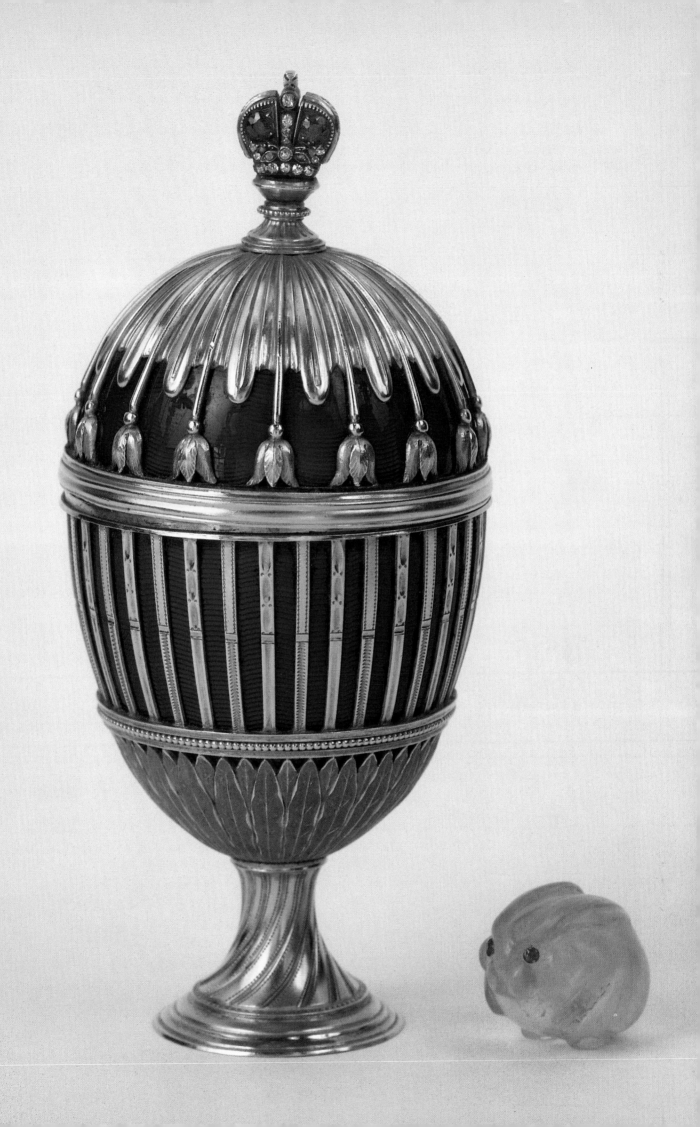

2 AZOVA EGG

St. Petersburg, 1891

WORKMASTERS: Michael Perchin and Yuri Nicolai

MARKS: FABERGÉ, M.P, 72, crossed anchors and scepter

MATERIALS/DIMENSIONS: Gold, platinum, diamond, rubies, heliotrope, aquamarine, velvet. Length $3^5/8''$ (9.3 cm)

TECHNIQUES: Casting, chasing, carving

State Museums of the Moscow Kremlin, inv. no. MP-645/I-2

DESCRIPTION: The egg is made from heliotrope with a superimposed gold pattern of rococo scrolls decorated with diamonds. The clasp consists of a ruby and two diamonds. The interior of the egg is lined with green velvet. The egg contains an exact replica of the cruiser *Pamiat Azova,* executed in gold and platinum, and with windows set with small diamonds. The name "Azov" appears on the stern of the ship, which rests on an aquamarine plate representing water. The plate has a golden frame with a loop enabling the model to be removed from the egg.

PROVENANCE: Presented by Czar Alexander III to his wife, Czarina Marie Feodorovna, Easter 1891.

REFERENCES: Snowman, 1962, pp. 82, 321-23 (ills.); Snowman, 1979, p. 91; Habsburg and Solodkoff, 1979, p. 157, no. 8; Solodkoff et al., 1984, pp. 61, 63 (ill.); Munich, 1986-87, p. 268, no. 535; Habsburg, 1987, p. 268, pl. 535; Solodkoff, 1988, pp. 34, 36 (ill.), 41.

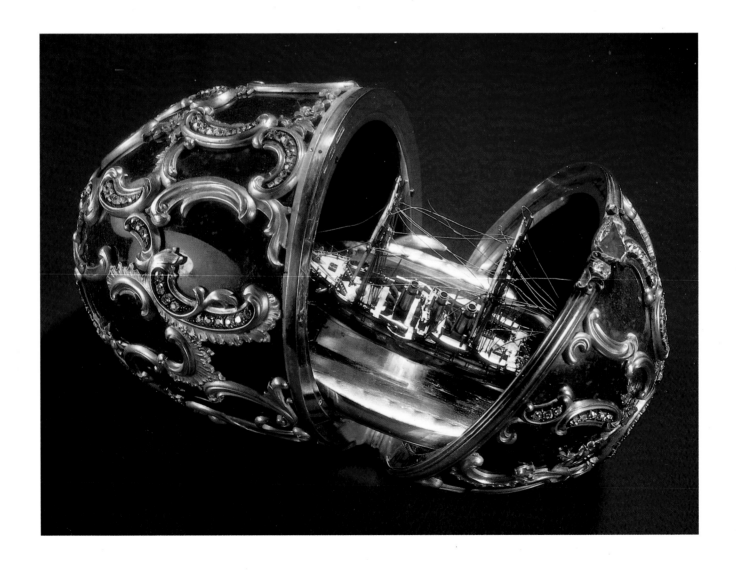

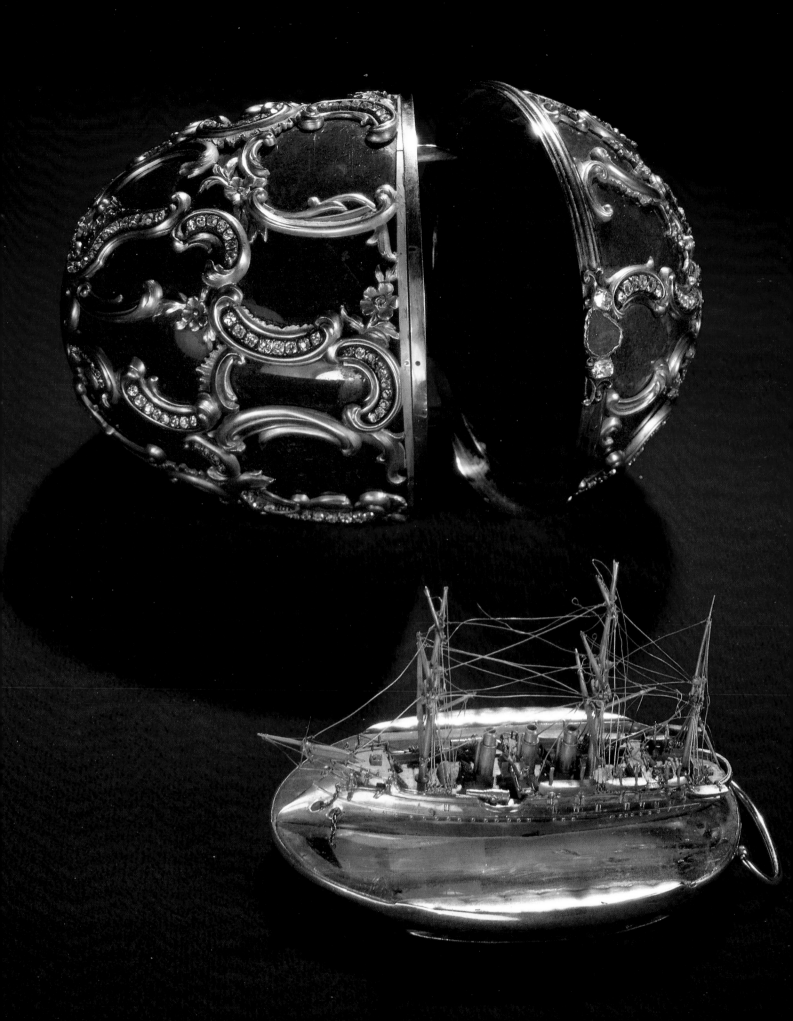

3 CAUCASUS EGG

St. Petersburg, 1893

WORKMASTER: Michael Perchin

MARKS: FABERGÉ, M.P, 72, crossed anchors and scepter

MATERIALS/DIMENSIONS: Egg: yellow and *quatre-couleur* gold, silver, platinum, transparent ruby enamel over a basket weave guilloché enamel ground, rose-cut diamonds, "portrait" or table diamonds, natural Oriental pearls, ivory, watercolor (?). Height $3^5/8''$ (9.2 cm)

TECHNIQUES: Transparent ruby guilloché enamel, watercolor (?) on ivory, casting, chasing

The Matilda Geddings Gray Foundation Collection, New Orleans (New Orleans Museum of Art)

DESCRIPTION: The late Louis XV-style egg bears four oval windows around its middle. Each window is covered with a conforming hinged oval panel bordered in pearls and centered with an oval diamond-set, ribbon-bound laurel wreath carrying a diamond numeral for the year 1893 at its center; each window and cover is flanked by a gold pearl terminal diamond-banded baton. The top of the egg is centered with a large "portrait" diamond covering an image of Grand Duke George Alexandrovich (1871-1899), younger brother of Czar Nicholas II. Rose-cut diamonds and a laurel-leaf wreath encircle the portrait diamond. On the shoulder of the egg rests a swagged rose garland of *quatre-couleur* gold caught with diamond-set platinum bowknots with a rose spray pendant. The lower quadrant of the egg is similarly decorated with a smaller portrait diamond at the base.

Each cover opens to reveal a painted ivory miniature of a different view of the imperial hunting lodge Abastuman in the Caucasus, to which Grand Duke George was sent for health reasons, having been diagnosed with tuberculosis. The views are by the court miniaturist K. Krijitski, and each is signed and dated 1891.

The whole is supported on a *faux*-bentwood scrolled gold stand that is not original.

PROVENANCE: Presented by Czar Alexander III to his wife, Czarina Marie Feodorovna, Easter 1893; purchased by Hammer Galleries, New York, from the Soviet government, circa 1927.

REFERENCES: New York, 1937, p. 5, no. 1; New York, 1951, p. 25 (ill.), no. 155; Bainbridge, 1966, pl. 57; London, 1977, pp. 80, 82 (ill.), no. M12; Waterfield and Forbes, 1978, p. 116 (ill.); Habsburg and Solodkoff, 1979, pp. 157, no. 10, 160 (ill.); Snowman, 1979, p. 91 (ill.); Forbes, 1980, pp. 34, 35 (ill.); Solodkoff et al., 1984, p. 67 (ill.).

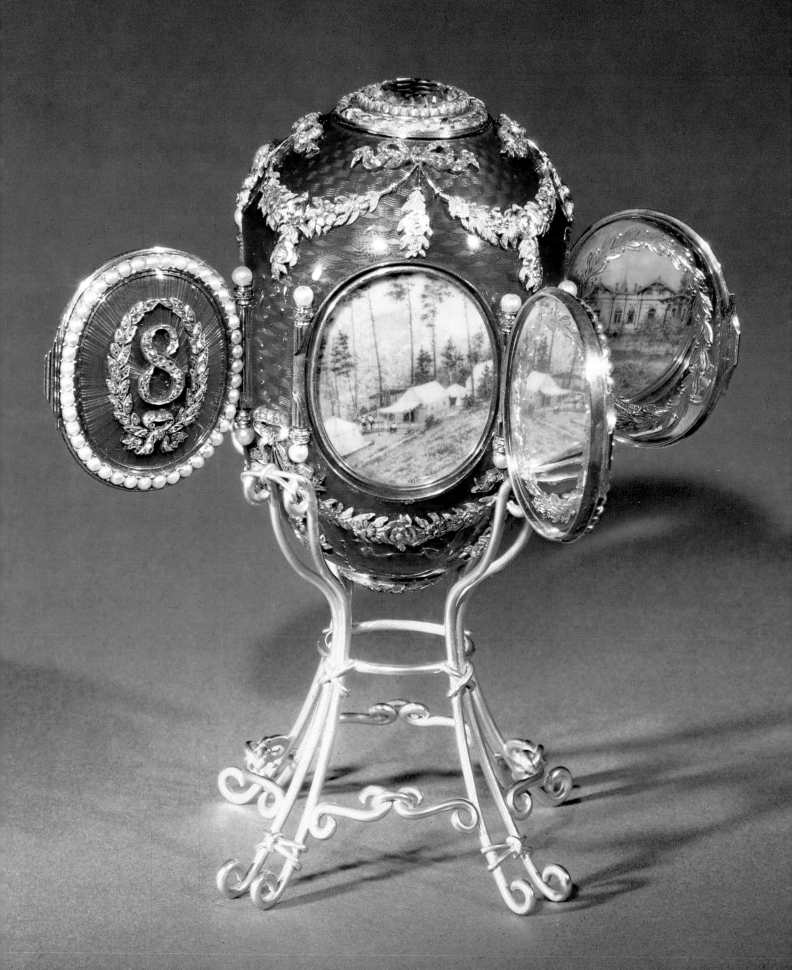

4 RENAISSANCE EGG

St. Petersburg, 1894

WORKMASTER: Michael Perchin

MARKS: FABERGÉ, M.P, 56, crossed anchors and scepter

MATERIALS/DIMENSIONS: White agate, gold, translucent green, red, and blue enamel, opaque black and white enamel, diamonds, rubies. Height 5¹/₂″ (14 cm)

TECHNIQUES: Translucent and opaque enamel, carving, chasing

The Forbes Magazine Collection, New York

DESCRIPTION: This casket in the Renaissance style is the last of the eggs made for Czar Alexander III, who died less than eight months after its presentation. It is modeled after an eighteenth-century casket by Le Roy, now in the Green Vaults, Dresden. The whereabouts and the nature of the egg's surprise are unknown.

PROVENANCE: Presented by Czar Alexander III to his wife, Czarina Marie Feodorovna, Easter 1894; purchased by Armand Hammer, circa 1927; Mr. and Mrs. Henry Talbot de Vere Clifton, England; Mr. and Mrs. Jack Linsky, New York; A La Vieille Russie, Inc., New York.

REFERENCES: Baltimore, 1983-84, no. 75; Detroit, 1984, no. 133; Solodkoff et al., 1984, pp. 61, 62, 68 (ill.); Kelly, 1985, p. 14; Funck, 1986, p. 310 (ill.); Munich, 1986-87, p. 272, no. 538; Forbes, 1987, pp. 11, 14 (ill.); London, 1987; Lugano, 1987, pp. 108, 109 (ills.), no. 117; Paris, 1987, pp. 104, 105 (ills.), no. 117; Forbes, 1988, pp. 36, 38 (ill.); Solodkoff, 1988, pp. 14 (ill.), 41.

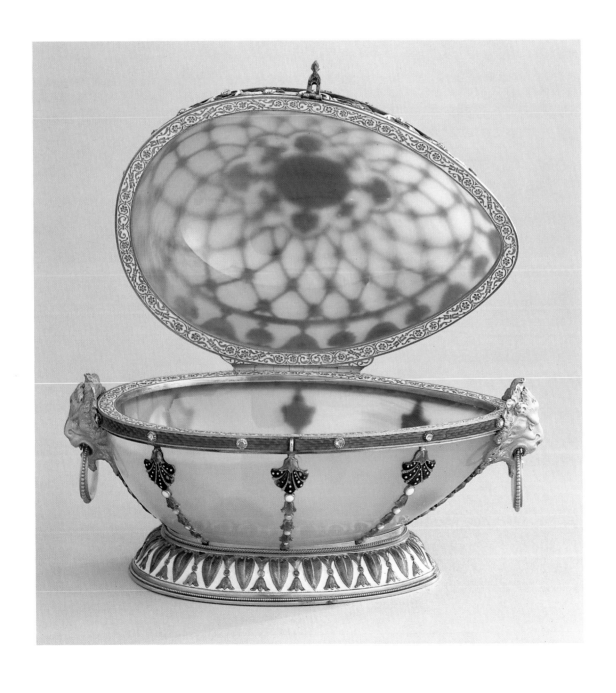

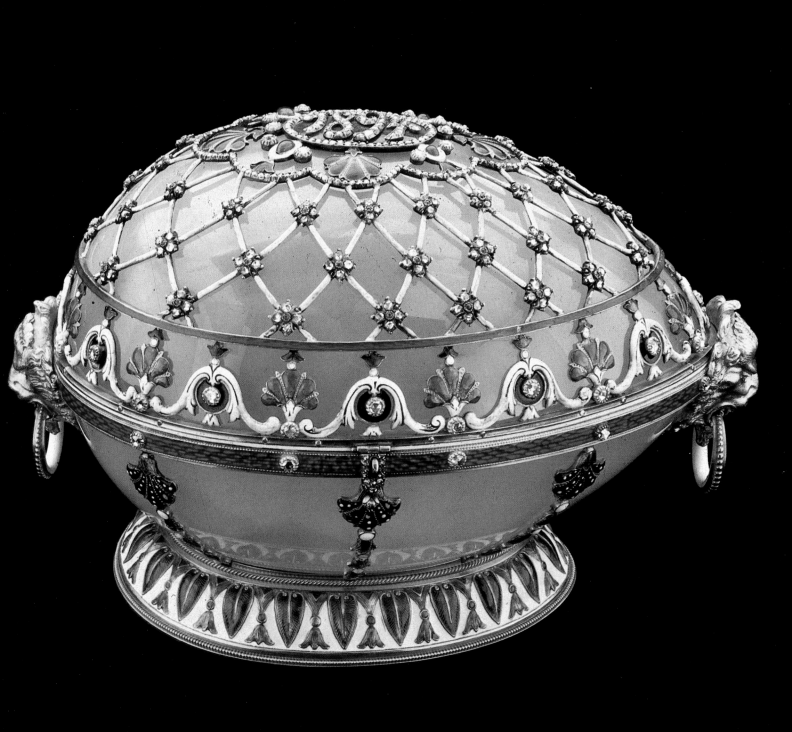

5 ROSEBUD EGG

St. Petersburg, 1895

WORKMASTER: Michael Perchin

MARKS: FABERGÉ, M.P, 56, crossed anchors and scepter

MATERIALS/DIMENSIONS: Egg: Varicolor gold, translucent red and opaque white enamel, diamonds, velvet lining. Height 2⁵/₈″ (6.8 cm). Rosebud: Gold, opaque green and yellow enamel

TECHNIQUES: Translucent enamel over a guilloché ground, opaque enamel, carving, chasing

The Forbes Magazine Collection, New York

DESCRIPTION: Its whereabouts unknown for decades, the Rosebud Egg was the first to be presented by Czar Nicholas II to his czarina. A miniature of Czar Nicholas II surmounts the egg, and the year is set in the base beneath a diamond. The egg opens to reveal a hinged yellow rosebud, which in turn originally contained two tiny surprises, a miniature replica of the imperial crown and a ruby egg pendant hanging within it. Like the almost identical crown and pendant of the first imperial egg, these two surprises were separated from the egg before it was sold by the Soviet government in the 1920s; their present whereabouts are unknown.

PROVENANCE: Presented by Czar Nicholas II to his wife, Czarina Alexandra Feodorovna, Easter 1895; Wartski, London; Charles Parsons, England; Mr. and Mrs. Henry Talbot de Vere Clifton, England; The Fine Art Society, London.

REFERENCES: London, 1935, p. 110, no. 578; Forbes, 1980, p. 61 (ill.); Solodkoff et al., 1984, p. 69 (ill.); Forbes, 1986, p. 56, cover; Munich, 1986-87, p. 270, no. 536; Forbes, 1987, pp. 12, 14 (ill.); London, 1987; Lugano, 1987, pp. 110, 111 (ills.), no. 118; Paris, 1987, pp. 106 (ill.), 107, no. 118; Forbes, 1988, pp. 42 (ill.), 43; Solodkoff, 1988, pp. 37 (ill.), 42.

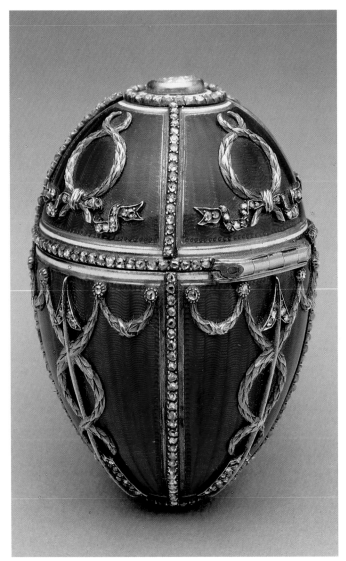

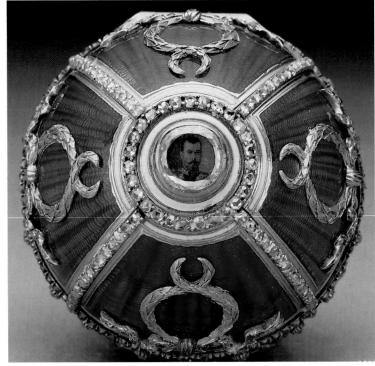

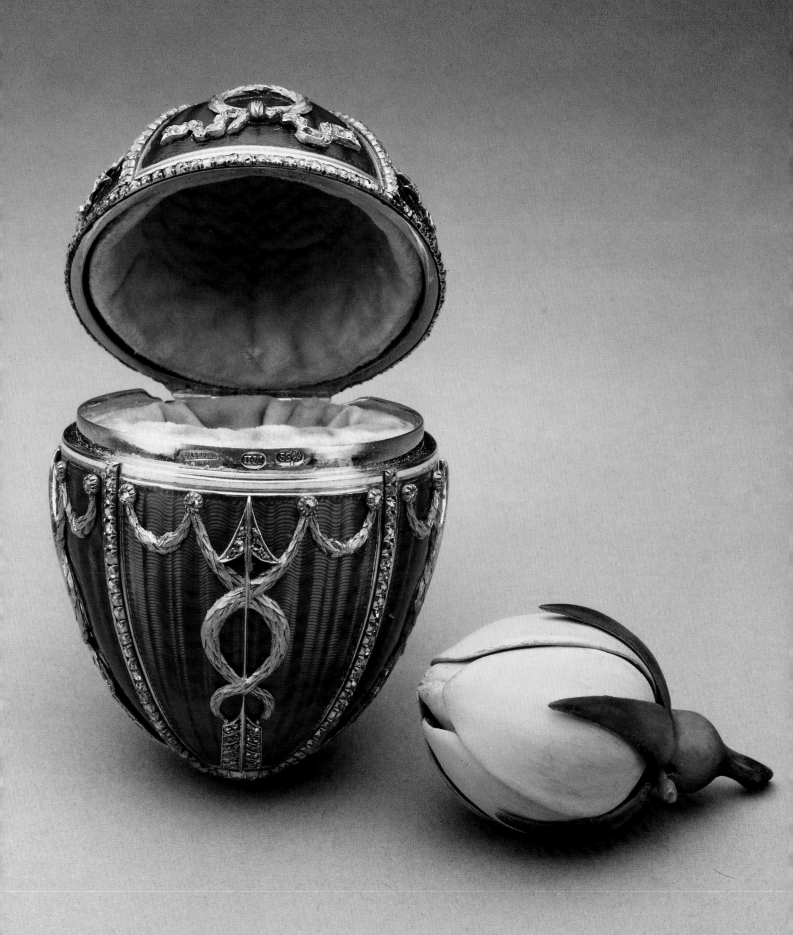

6 DANISH PALACE EGG

St. Petersburg, 1895

WORKMASTER: Michael Perchin

MARKS: FABERGÉ, M.P, 56, crossed anchors and scepter

MATERIALS/DIMENSIONS: Egg: Green and rose gold, mauve opalescent guilloché enamel, star sapphire, emerald, rose-cut diamonds, red velvet pocket and lining. Height 4″ (10.1 cm). Screen: Green and *quatre-couleur* rose gold, watercolor (?) on mother-of-pearl

TECHNIQUES: Transparent enamel over a guilloché ground of cross repeats, casting, chasing

The Matilda Geddings Gray Foundation Collection, New Orleans (New Orleans Museum of Art)

DESCRIPTION: The Louis XVI-style egg is divided into twelve sections by six vertical and three horizontal fillets of rose-cut diamonds between two fillets of chased laurel leaves. Each intersection is marked by a cabochon emerald with a rose gold fleurette at each corner. The egg terminates in a medallion of radiating chased acanthus leaves centered with a diamond-ringed blue-gray cabochon star sapphire. The base of the egg is embellished with a medallion of chased swirling acanthus leaves.

The egg opens to reveal a folding ten-panel screen, whose frames are formed of reticulated tangent circles, rest on Greek Meander feet, and are surmounted by a chased *quatre-couleur* floral wreath flanked by two branches of chased laurel leaves. The panels, painted by the court miniaturist K. Krijitski and signed and dated 1891, depict, from left to right: the imperial yacht *Polar Star*; Amaliensborg Palace, Copenhagen; the estate of Hvidøre; the summer residence of Fredensborg Castle; Bernstorff Castle; Kronborg Castle, Elsinore; Dacha Alexandria, Peterhof; Dacha Gatchina, near St. Petersburg; Gatchina Palace, near St. Petersburg; the imperial yacht *Tsarevna*.

PROVENANCE: Presented by Czar Nicholas II to his mother, Dowager Czarina Marie Feodorovna, Easter 1895; purchased by Hammer Galleries, New York, from the Soviet government, circa 1927; Mr. and Mrs. Nicholas H. Ludwig.

REFERENCES: New York, 1937, p. 5, no. 3; New York, 1939, ill.; New York, 1949, no. 129; New York, 1951, p. 28 (ill.), no. 157; Bainbridge, 1966, pl. 65; London, 1977, no. M8; Waterfield and Forbes, 1978, p. 117 (ill.); Habsburg and Solodkoff, 1979, pp. 157, no. 12, 160 (ill.); Snowman, 1979, p. 95; Solodkoff et al., 1984, p. 70 f.; Munich, 1986-87, p. 271 (ill.), no. 537.

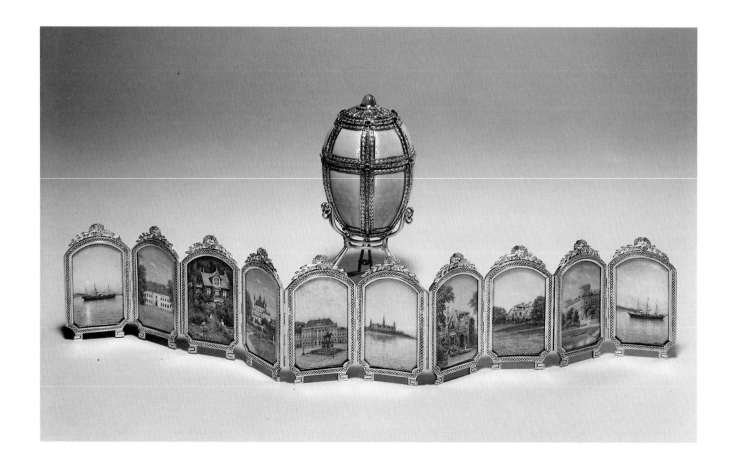

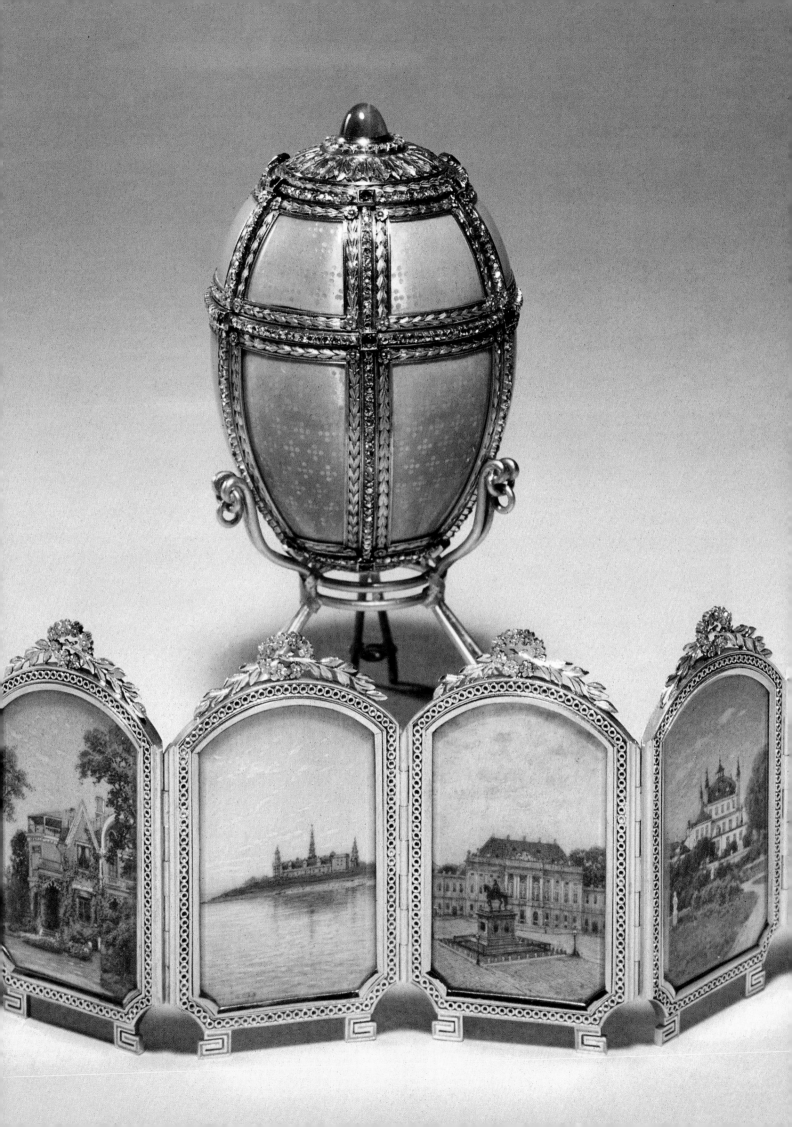

7 CORONATION EGG

St. Petersburg, 1897

WORKMASTERS: Michael Perchin and Henrik Wigström

MARKS: M. P, 56, crossed anchors and scepter, Wigström [roughly scratched on the inner surface of the shell]

MATERIALS/DIMENSIONS: Egg: Varicolor gold, translucent lime yellow and opaque black enamel, diamonds, velvet lining. Height 5″ (12.6 cm). Coach: Gold, platinum, strawberry red enamel, diamonds, rubies, rock crystal. Length 3^{11}/$_{16}$″ (9.3 cm)

TECHNIQUES: Translucent enamel over a guilloché ground, opaque enamel, chasing

The Forbes Magazine Collection, New York

DESCRIPTION: The egg opens to reveal a removable miniature replica by George Stein of the coach used for the czar and czarina's coronation in 1896. The color scheme of the egg is an allusion to the czarina's coronation gown. A tiny egg, pavé-set with brilliants, once hung inside the coach. Beneath a portrait diamond set at the top of the egg, the monogram of Czarina Alexandra Feodorovna is set in rose diamonds and rubies. The date is inscribed beneath a smaller portrait diamond at the bottom of the egg.

PROVENANCE: Presented by Czar Nicholas II to his wife, Czarina Alexandra Feodorovna, Easter 1897; purchased by Emanuel Snowman for Wartski, London, circa 1927.

REFERENCES: Forbes, 1979, pp. 1237, 1238; Fort Worth, 1983, no. 189; Detroit, 1984, no. 134; Kelly, 1985, pp. 14 (ill.), 15; Funck, 1986, p. 309 (ill.); Munich, 1986-87, pp. 272, 273 (ill.), no. 539; Forbes, 1987, pp. 11, 14 (ill.); London, 1987; Lugano, 1987, pp. 112, 113 (ills.), no. 119; Paris, 1987, pp. 108 (ill.), 109, no. 119; Forbes, 1988, pp. 37 (ill.), 43; Solodkoff, 1988, pp. 27, 34 (ill.), 38, 43, 119.

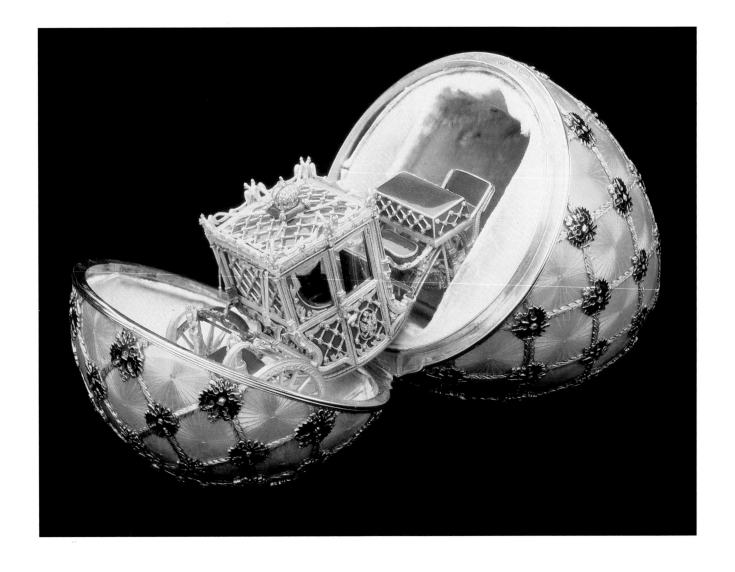

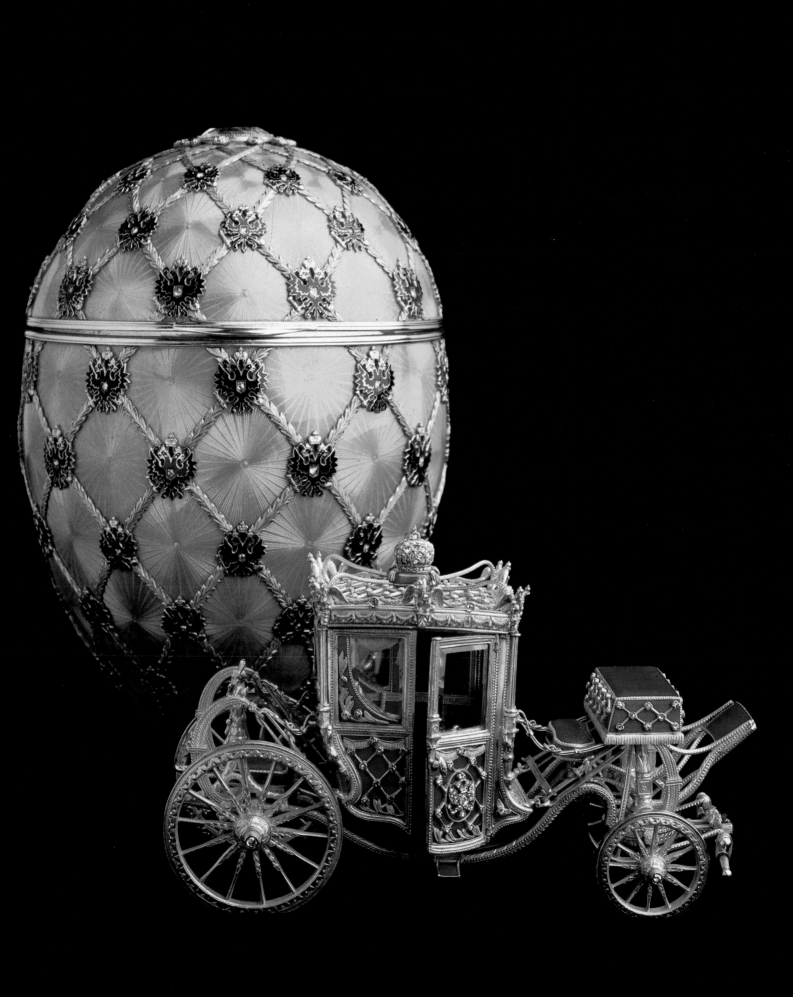

8 LILIES OF THE VALLEY EGG

St. Petersburg, 1898

WORKMASTER: Michael Perchin

MARKS: M.P, 56, crossed anchors and scepter

MATERIALS/DIMENSIONS: Gold, translucent pink and green enamel, diamonds, rubies, pearls, rock crystal, ivory. Height 7⁷/₈″ (20 cm) (open)

TECHNIQUES: Translucent enamel over a guilloché ground, chasing, painting on ivory

The Forbes Magazine Collection, New York

DESCRIPTION: The surprise of the art nouveau-style Lilies of the Valley Egg is a trio of miniature portraits of Czar Nicholas II and his two eldest daughters, grand duchesses Olga and Tatiana, by Johannes Zehngraf, which rise out of the egg when a pearl "button" is turned. The date is engraved on the reverse of the miniatures.

PROVENANCE: Presented by Czar Nicholas II to his mother, Dowager Czarina Marie Feodorovna, Easter 1898; purchased by Emanuel Snowman for Wartski, London, circa 1927.

REFERENCES: London, 1977, pp. 93, 101, no. 02; Boston, 1979 (ill.); Forbes, 1979, p. 1237, pl. XVI; New York, 1983, pp. 143 (ill.), 144, no. 556; Baltimore, 1983-84, no. 76; Fort Worth, 1984, no. 190; Solodkoff et al., 1984, pp. 64, 76 (ill.); Kelly, 1985, p. 25 (ill.); Forbes, 1987, p. 11; Paris, 1987; Forbes, 1988, pp. 39 (ill.), 43; Solodkoff, 1988, pp. 31 (ill.), 34, 42.

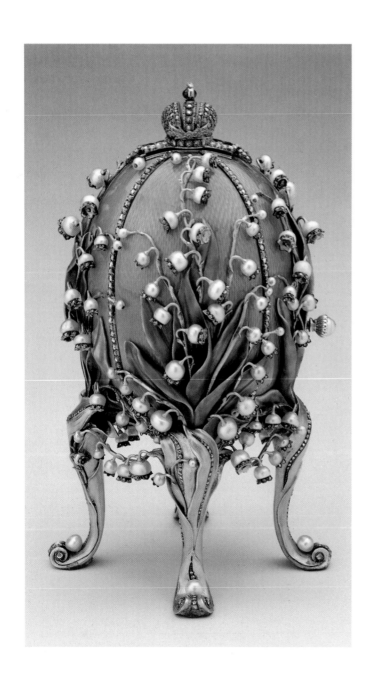

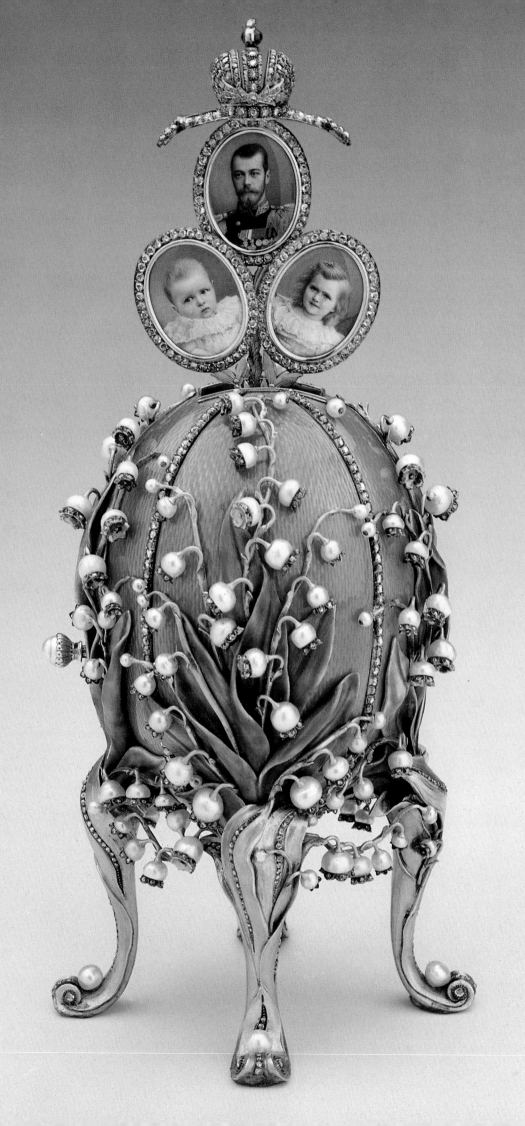

9 SPRING FLOWERS EGG

St. Petersburg, before 1899

WORKMASTER: Michael Perchin

MARKS: FABERGÉ, M.P, 56, crossed anchors and scepter, 44 374

MATERIALS/DIMENSIONS: Egg: Varicolor gold, platinum, translucent strawberry red enamel, diamonds, bowenite. Height 3¹/₄″ (8.3 cm) Basket: Platinum, gold, translucent green enamel, white chalcedony, demantoids.

TECHNIQUES: Translucent enamel over a guilloché ground, chasing, carving

The Forbes Magazine Collection, New York

DESCRIPTION: The shell of the Spring Flowers Egg parts to reveal a miniature bouquet of wood anemones in a platinum basket. A similar basket of flowers was used for the surprise in the Winter Egg given by Czar Nicholas II to his mother, Dowager Czarina Marie Feodorovna, Easter 1913 (no. 38, p. 110).

PROVENANCE: Presented by Czar Alexander III to his wife, Czarina Marie Feodorovna, Easter 1886/92; Lansdell K. Christie, Long Island; A La Vieille Russie, Inc., New York.

REFERENCES: New York, 1973, pp. 4, 26, 27 (ill.), no. 1; London, 1977, p. 73, no. L8; Boston, 1979; Forbes, 1979, p. 1237, pl. XIV; Chicago, 1983, p. 17, no. 94; Fort Worth, 1983, no. 187; Minneapolis, 1983, p. 17, no. 94; Richmond, 1983, p. 17, no. 94; Detroit, 1984, no. 132; Solodkoff et al., 1984, pp. 58-59 (ills.); Kelly, 1985, p. 14; Funck, 1986, p. 311 (ill.); Forbes, 1988, pp. 40, 41; Solodkoff, 1988, p. 41 (ill.).

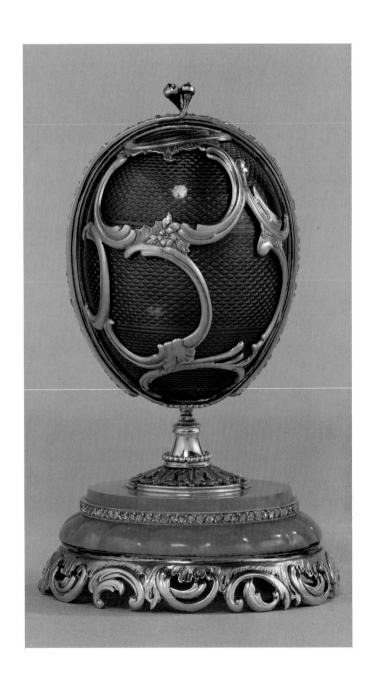

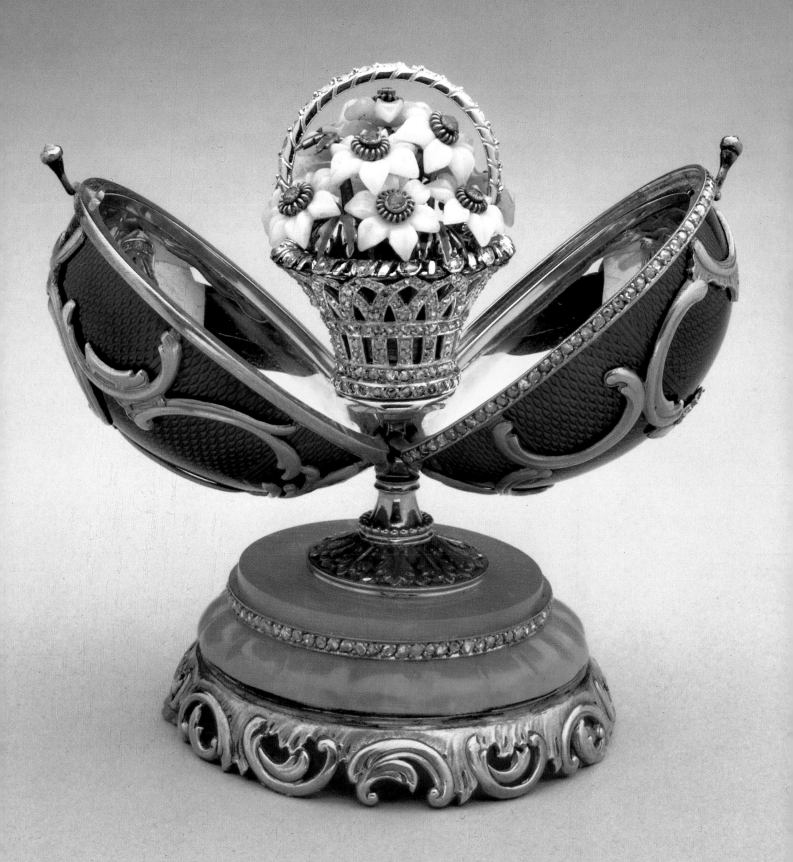

10 MADONNA LILY EGG

St. Petersburg, 1899

WORKMASTER: Michael Perchin

MARKS: FABERGÉ, M. P, Y. L. [initials of inspector Yakova Lyapunova of St. Petersburg Standard Board], 56, kokoshnik

MATERIALS/DIMENSIONS: Gold, platinum, silver, rosettes, onyx. Height 10⁵/₈″ (27 cm)

TECHNIQUES: Translucent enamel over a guilloché ground, casting, minting

State Museums of the Moscow Kremlin, inv. no. MP-653/I-2

DESCRIPTION: The rectangular pedestal and egg-shaped clock are decorated with yellow-gold translucent enamel on a guilloché background. The clock is crowned with a delicate bouquet of lilies, carved from onyx. The pistils of the flowers are set with three small diamonds, and the leaves and stems are of tinted gold. The body of the clock is divided into twelve parts which are outlined in diamond-studded stripes. The diamond clock hand is in the shape of an arrow which protrudes from an immobile base.

A diamond and enameled belt with twelve diamond-set Roman numerals revolves around the perimeter of the egg, indicating the time. The base is decorated with rosettes and the date of its manufacture, 1899, is set in diamonds. A gold key was used to wind the mechanism.

PROVENANCE: Presented by Czar Nicholas II to his wife, Czarina Alexandra Feodorovna, Easter 1899.

REFERENCES: Snowman, 1962, pp. 88 ff., 332 (ill.); *Armory*, 1964, p. 67; Goldberg et al., 1967, p. 61, no. 75; Ivanov, 1967, p. 75; Rodimtseva, 1971, pp. 5, no. 3, 11, no. 7; Donova, 1973, p. 178; Habsburg and Solodkoff, 1979, p. 105, pl. 127; Solodkoff et al., 1984, p. 77 (ill.); Solodkoff, 1988, p. 43.

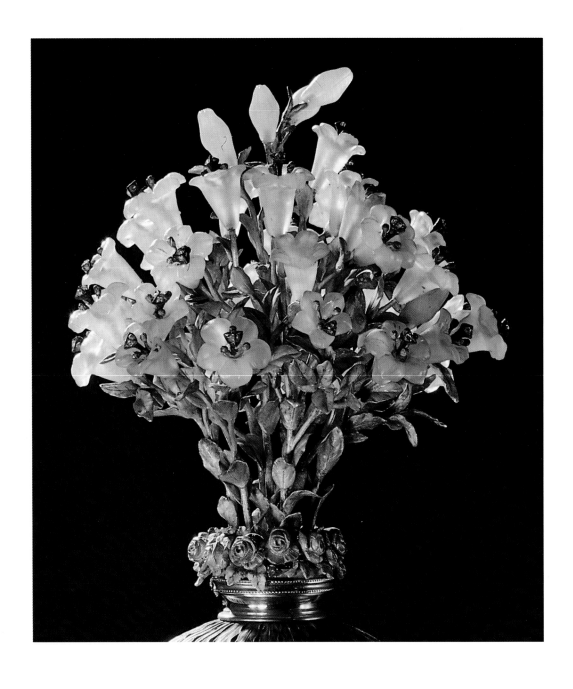

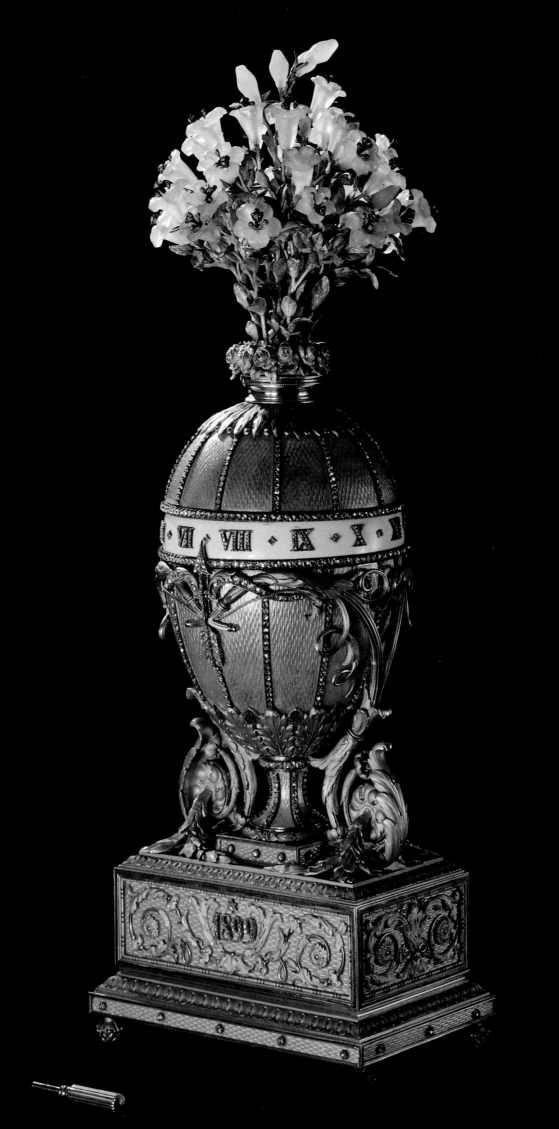

11 Pansy Egg

St. Petersburg, 1899

WORKMASTER: Michael Perchin

MARKS: 88, kokoshnik

MATERIALS/DIMENSIONS: Nephrite, silver-gilt, diamonds, white, red, green, and violet enamel. Height 5³/₄″ (14.6 cm)

TECHNIQUES: Guilloché, carving

Private collection, U.S.A.

DESCRIPTION: The surprise is a gold easel supporting a diamond-set and translucent white enamel heart on which are visible eleven red enamel, individually monogrammed ovals. Each oval forms a cover which, when opened, reveals a miniature of a member of the imperial family. Reading from left to right and top to bottom, the portraits depict: Grand Duke George, younger brother of the czar; Grand Duke Alexander, husband of Grand Duchess Xenia, the czar's sister; Czar Nicholas II; Grand Duchess Irina, subsequently Princess Youssoupoff, daughter of Grand Duke Alexander and Grand Duchess Xenia; Grand Duchess Olga, the first child of the czar and czarina; Grand Duchess Tatiana, their second child; Grand Duke Michael, youngest brother of the czar; the czarina; Grand Duke Andrew, brother of Grand Duchess Irina; Grand Duchesses Olga and Xenia, sisters of the czar.

PROVENANCE: Presented by Czar Nicholas II to his mother, Dowager Czarina Marie Feodorovna, Easter 1899; Hammer Galleries, New York, 1930s.

REFERENCES: Bainbridge, 1949, pl. 62; London, 1977, pp. 80, 85, 87 (ill.); Snowman, 1979, p. 100 (ill.); New York, 1983, pp. 144, 145 (ill.); Solodkoff et al., 1984, pp. 64, 78-79 (ills.); Solodkoff, 1988, pp. 17, 21, 34, 42.

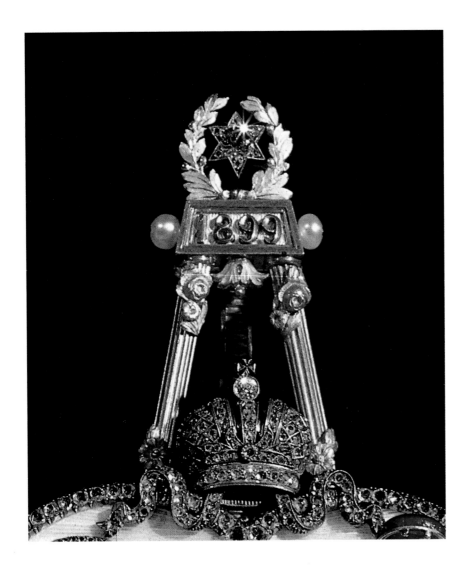

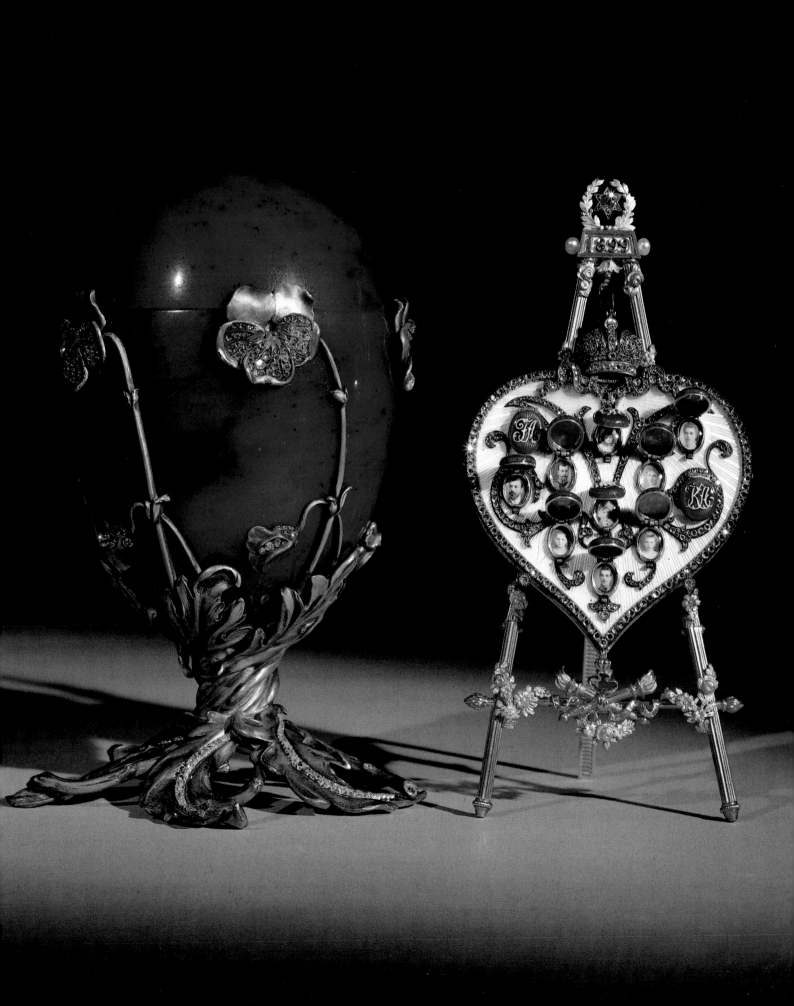

St. Petersburg, 1900

WORKMASTER: Michael Perchin

MARKS: FABERGÉ, M. P, 56, kokoshnik

MATERIALS/DIMENSIONS: Varicolor gold, translucent violet and green enamel, opalescent white and oyster enamel, opaque lilac enamel, diamonds, rubies, pearls, feathers. Height 8″ (20.3 cm) (open)

TECHNIQUES: Translucent and opalescent enamel over a guilloché ground, chasing, filigree

The Forbes Magazine Collection, New York

DESCRIPTION: The baroque-style Cuckoo Egg, fashioned as a table clock, is one of six automated imperial Easter eggs created by Fabergé. When a button is pushed, the grille at the top of the egg lifts to reveal a cockerel, which emerges crowing and flapping its wings.

PROVENANCE: Presented by Czar Nicholas II to his mother, Dowager Czarina Marie Feodorovna, Easter 1900; purchased by Emanuel Snowman for Wartski, London, circa 1927; private collection, U.S.A.; sold to anonymous buyer, Christie's, Geneva, November 20, 1973; Mr. and Mrs. Bernard C. Solomon, Los Angeles; Sotheby's, New York, June 11, 1985, Lot 478.

REFERENCES: Forbes, 1979, p. 1241, pl. XXII; Helsinki, 1980, p. 16 (ill.), no. 14; Fort Worth, 1983, no. 191; New York, 1983, pp. 144, 146 (ill.), no. 558; Kelly, 1985, pp. 13 (ill.), 14; Solodkoff, 1986, p. 37 (ill.); Munich, 1986-87, pp. 94, 99; Forbes, 1987, p. 12; Lugano, 1987, p. 16; Paris, 1987, p. 12; Forbes, 1988, p. 43; Solodkoff, 1988, pp. 28 (ill.), 37, 42, 98.

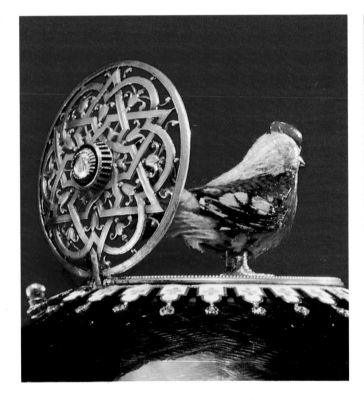

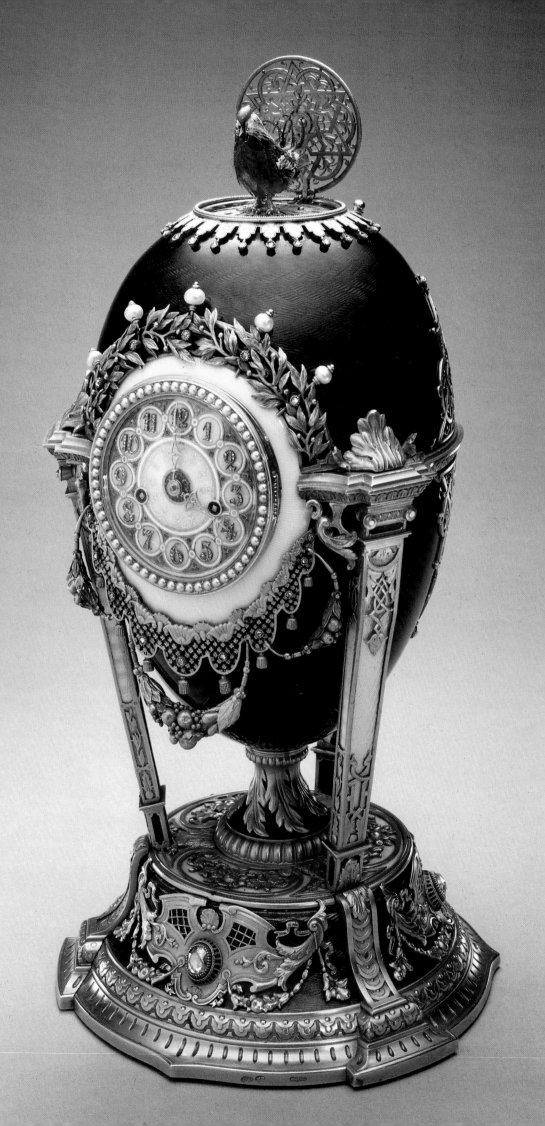

St. Petersburg, 1900

WORKMASTER: Michael Perchin

MARKS: FABERGÉ, M.P, Y.L. [initials of inspector Yakova Lyapunova of St. Petersburg Standard Board], 56, kokoshnik

MATERIALS/DIMENSIONS: Gold, platinum, tinted gold, silver, rosettes, rubies, onyx, crystal. Height 10^1/$_4$″ (26 cm), length of train 15^3/$_4$″ (39.8 cm)

TECHNIQUES: Translucent enamel over a guilloché ground, casting, engraving, filigree

State Museums of the Moscow Kremlin, inv. no. MP-646/I-3

DESCRIPTION: The silver egg with a hinged lid is decorated with colored enamel and mounted on an onyx base. A map of Russia is engraved with the route of the Trans-Siberian Railway on the central silver section, which also bears the inscription "The route of the Grand Siberian Railway in the year 1900."

The lid of the egg is hinged, has an overlay of green enamel, and is decorated with inlaid leaves of acanthus. A three-sided her-aldic eagle in silver and gold plate rises from the lid, bearing a crown. The egg is supported by three griffins cast in gold-plated silver, each brandishing a sword and shield. The stepped base is of white onyx in the form of a triangle with concave sides and rounded corners. A gold-plated silver plait is inlaid into the base.

A working model of the train is inserted into the egg section by section. It consists of a platinum locomotive with a ruby lantern and rosette headlights and of five gold coaches with windows of rock crystal. The coaches are marked "mail," "for ladies only," "smoking," and "non-smoking." The last coach is designated "chapel." The train was wound up with a golden key.

PROVENANCE: Presented by Czar Nicholas II to his wife, Czarina Alexandra Feodorovna, Easter 1900.

REFERENCES: Snowman, 1962, pp. 91, 336 (ill.); *Armory*, 1964, p. 168; Goldberg et al., 1967, pp. 61, 139, 202-3; Rodimtseva, 1971, p. I, no. I; Donova, 1973, p. 178; Habsburg and Solodkoff, 1979, pp. 157, no. 40, 163 (ill.); Snowman, 1979, p. 102; Solodkoff et al., 1984, pp. 65, 82 ff.; Munich, 1986-87, p. 274, no. 540; Habsburg, 1987, p. 274, pl. 540; Solodkoff, 1988, pp. 27 (ill.), 28, 43.

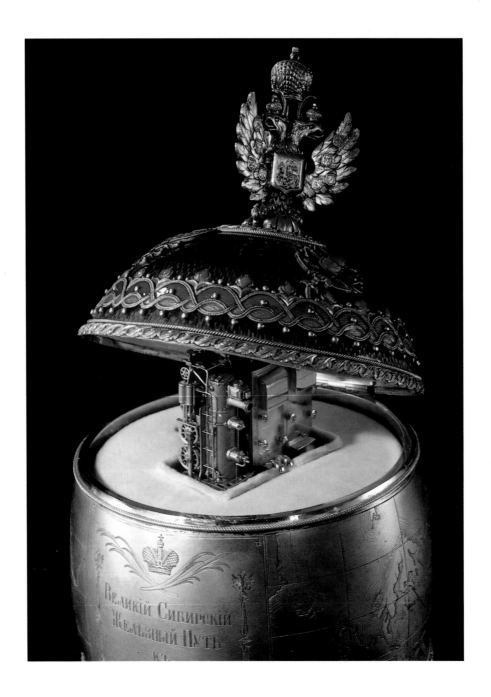

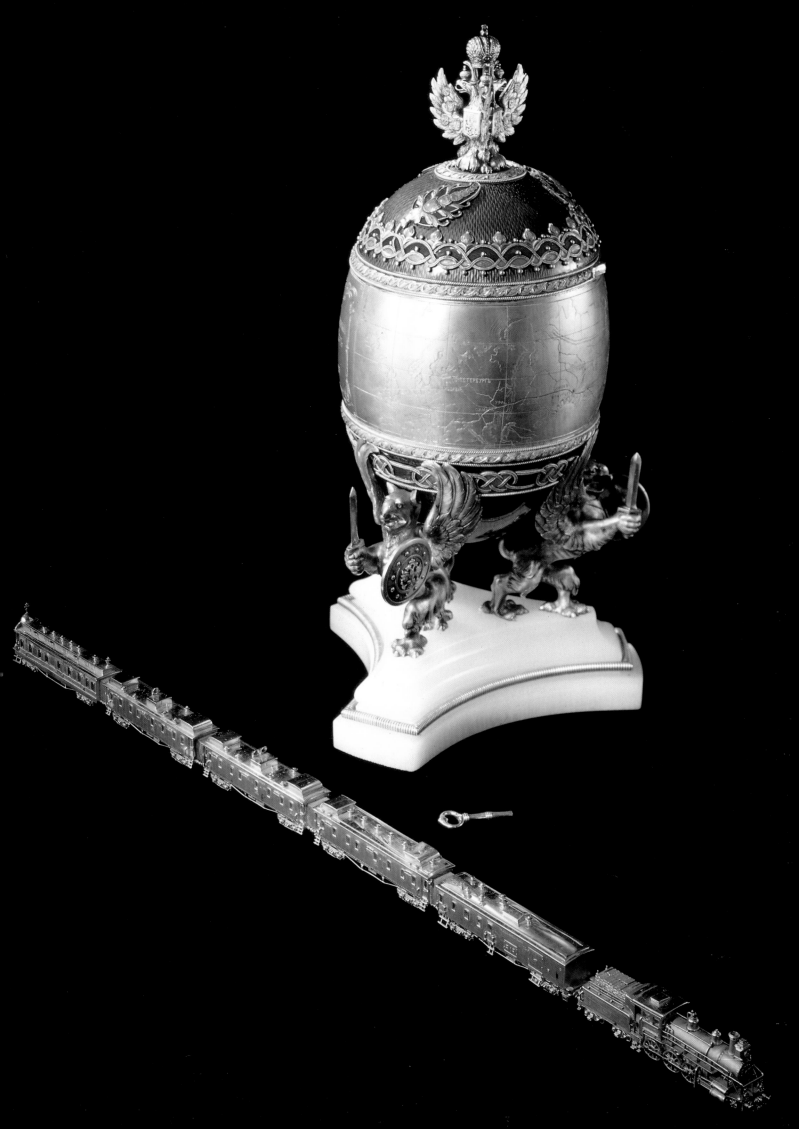

14 COLONNADE EGG

St. Petersburg, probably 1905

WORKMASTER: Henrik Wigström

MARKS: H. W., 56, kokoshnik

MATERIALS/DIMENSIONS: Bowenite, four-color gold, rose diamonds, silver-gilt, platinum. Height $11^1/4''$ (28.6 cm)

TECHNIQUES: Enameling, engraving, casting, chasing, carving

Her Majesty Queen Elizabeth II

DESCRIPTION: Conceived as an arcadian Temple of Love, this rotary clock egg commemorates the birth of the long-awaited heir to the throne in 1904. A silver-gilt cupid, an allegorical representation of the czarevitch, surmounts the gold egg, which is enameled opalescent pale pink on an engraved ground and is encircled by the broad band of a translucent white enameled dial set with rose diamond numerals; a diamond-set pointer projects from a colonnade in pale green bowenite, which supports the egg. The base of this colonnade, which is made up of six gold-mounted Ionic columns, is set with colored gold chiseled mounts and a broad band of pale pink enamel. Four silver-gilt cherubs, representing the czar's four daughters, are seated at intervals around this elaborate base and are linked by floral swags chiseled in *quatre-couleur* gold. Two cast and chased platinum doves are perched on a white enamel plinth raised within the circle of columns.

Sir Sacheverell Sitwell has suggested that the design for this egg derives from Eisen's illustrations to *Les Baisers* of Dorat.

PROVENANCE: Presented by Czar Nicholas II to his wife, Czarina Alexandra Feodorovna, probably Easter 1905; purchased by Queen Mary, 1929.

REFERENCES: Bainbridge, 1949, pl. 61; Snowman, 1962, pp. 25, 96, pl. LXXVII; London, 1977, pp. 49, 51 (ill.); Snowman, 1979, pp. 95, 96, 105 (ill.), 121; Snowman, 1983, pp. 56, 57 (ill.); Solodkoff et al., 1984, pp. 91 (ill.), 109; Solodkoff, 1988, pp. 12, 44 (ill.), 45.

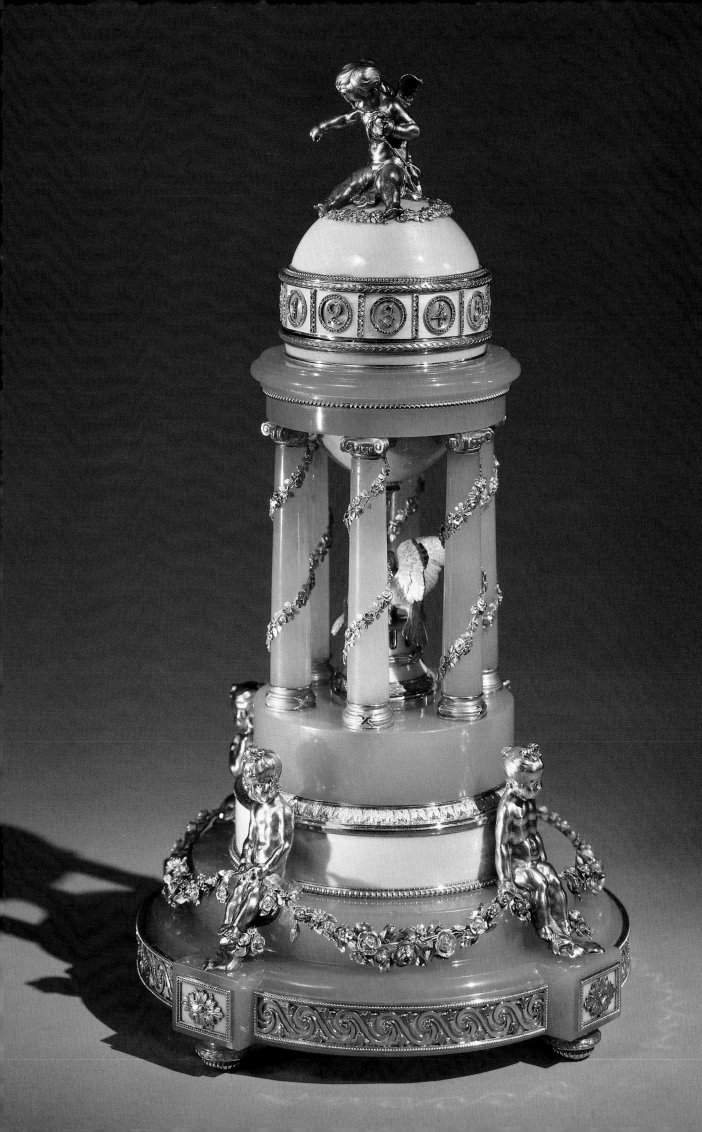

15 EGG WITH LOVE TROPHIES

St. Petersburg, 1905 or 1910

WORKMASTER: Henrik Wigström

MARKS: H. W., kokoshnik

MATERIALS/DIMENSIONS: Varicolor gold, translucent pale blue and green enamel, opalescent oyster enamel, diamonds, rubies, pearls, white onyx. Height $5^3/4''$ (14.7 cm)

TECHNIQUES: Translucent and opalescent enamel over a guilloché ground, chasing, carving

Private collection

DESCRIPTION: Created in the Louis XVI style, the Egg with Love Trophies is surmounted by a gold basket of enameled roses and encircled by four quivers of arrows linked by rose-and-foliage swags. The original surprise, a gold, enameled miniature heart-shaped frame with a strut forming the name Niki, has been lost. This exhibition marks the first time the Egg with Love Trophies has been shown to the public in fifty years. As the egg has not been readily available for examination of the marks, there is some question as to the date of presentation to Czarina Alexandra Feodorovna.

PROVENANCE: Presented by Czar Nicholas II to his wife, Czarina Alexandra Feodorovna, Easter 1905 or 1910.

REFERENCES: Snowman, 1953, p. 96, nos. 332, 333; Snowman, 1962/64/68/74, pp. 99, 100, nos. 361, 362; Waterfield and Forbes, 1978, p. 124 (ill.); Forbes, 1979, pp. 1236 (ill.), 1241; Habsburg and Solodkoff, 1979, pp. 158, no. 50, 164 (ill.); Snowman, 1979, pp. 94, 96, 104 (ill.); Forbes, 1980, p. 66 (ill.); Solodkoff, 1984, p. 90 (ill.); Solodkoff, 1988, pp. 37, 45.

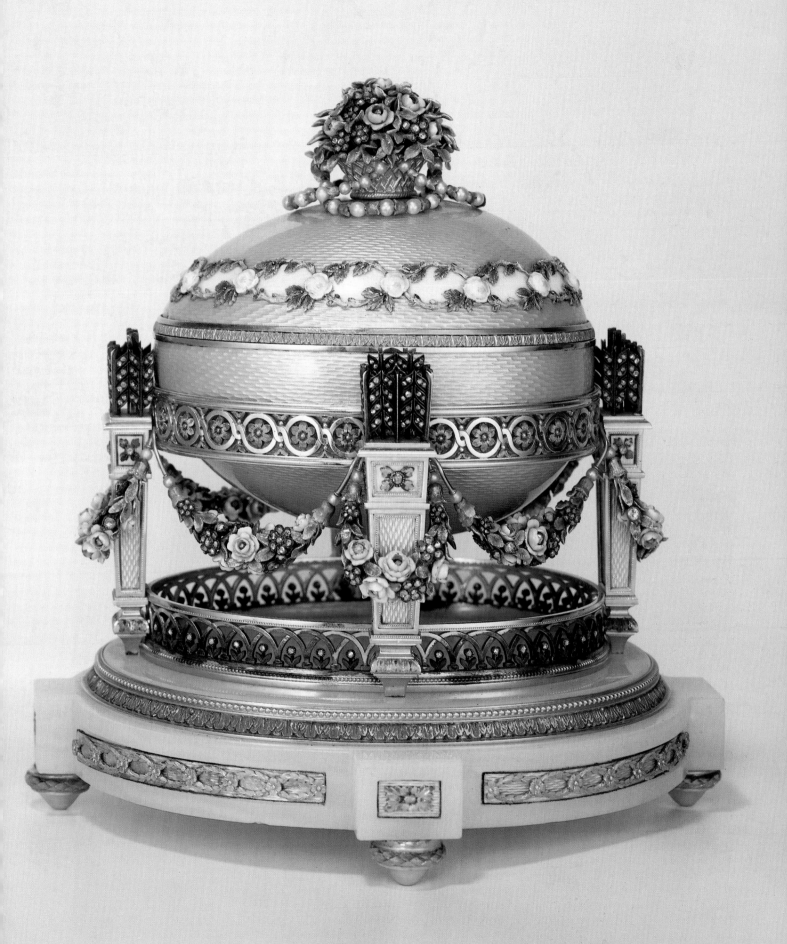

St. Petersburg, 1908

WORKMASTER: Henrik Wigström

MARKS: FABERGÉ, H. W., Y. L. [initials of inspector Yakova Lyapunova of St. Petersburg Standard Board], 72, kokoshnik

MATERIALS/DIMENSIONS: Gold, silver, diamonds, rosettes, rubies, nephrite, rock crystal, ivory. Height 4³/₈″ (11 cm)

TECHNIQUES: Casting, minting, engraving, miniature painting, stone cutting

State Museums of the Moscow Kremlin, inv. no. MR 648

DESCRIPTION: The nephrite egg is adorned with five miniature portraits of the children of Czar Nicholas II and contains a replica of Alexander Palace at Czarskoe Selo.

The upper and lower sections of the egg are set with triangular diamonds bearing the initials A. F. (Alexandra Feodorovna) and the date 1908. Each diamond is surrounded by an inlaid wreath of golden leaves and flowers composed of rubies and diamonds. The remainder of the egg's surface is divided by five vertical lines, studded with diamonds and connected with one another by gold garlands inlaid with rose and ruby flowers.

In the spaces between the vertical lines are five miniature oval portraits of Czar Nicholas II's children, executed in watercolor on ivory and framed in diamonds. Above each portrait is a crowned diamond monogram – the first initial of the child represented. Two gold branches tied into a bow rest beneath each child's portrait. Inside the egg, on the reverse side of each portrait, is engraved the birth date of the person represented, framed by two branches tied into a bow: "Olga" – November 3, 1895; "Tatiana" – May 29, 1897; "Maria" – June 14, 1899; "Anastasia" – June 5, 1901; "Alexei" – July 30, 1904.

The replica of Alexander Palace and its adjoining gardens can be concealed within the egg. Executed in tinted gold and enamel, the model is secured on a round pedestal with five high narrow legs that are connected at the bottom. The inscription "The Palace at Czarskoe Selo," enclosed in a laurel wreath, is engraved on the base.

PROVENANCE: Presented by Czar Nicholas II to his wife, Czarina Alexandra Feodorovna, Easter 1908.

REFERENCES: Snowman, 1962, pp. 98, 353-55 (ills.); Rodimtseva, 1971, p. 15, no. 9; Habsburg and Solodkoff, 1979, pp. 158, no. 48, 164 (ill.); Solodkoff et al., 1984, pp. 64, 93 (ill.); Solodkoff, 1988, pp. 26, 45.

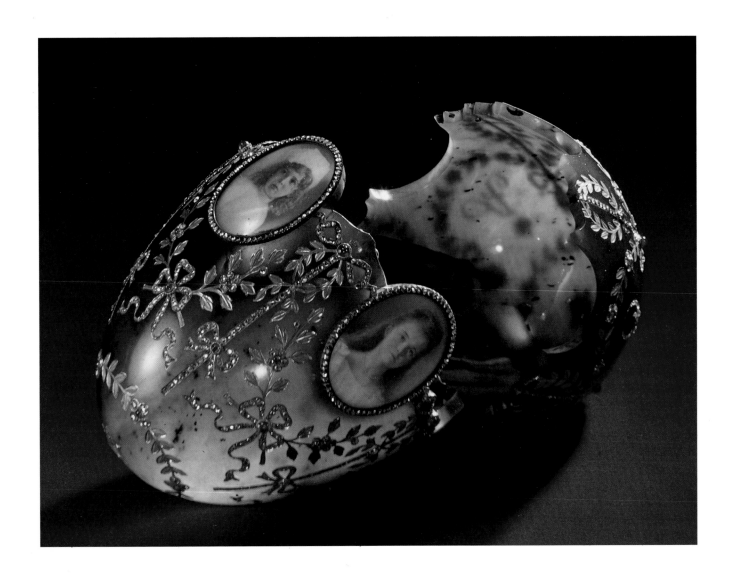

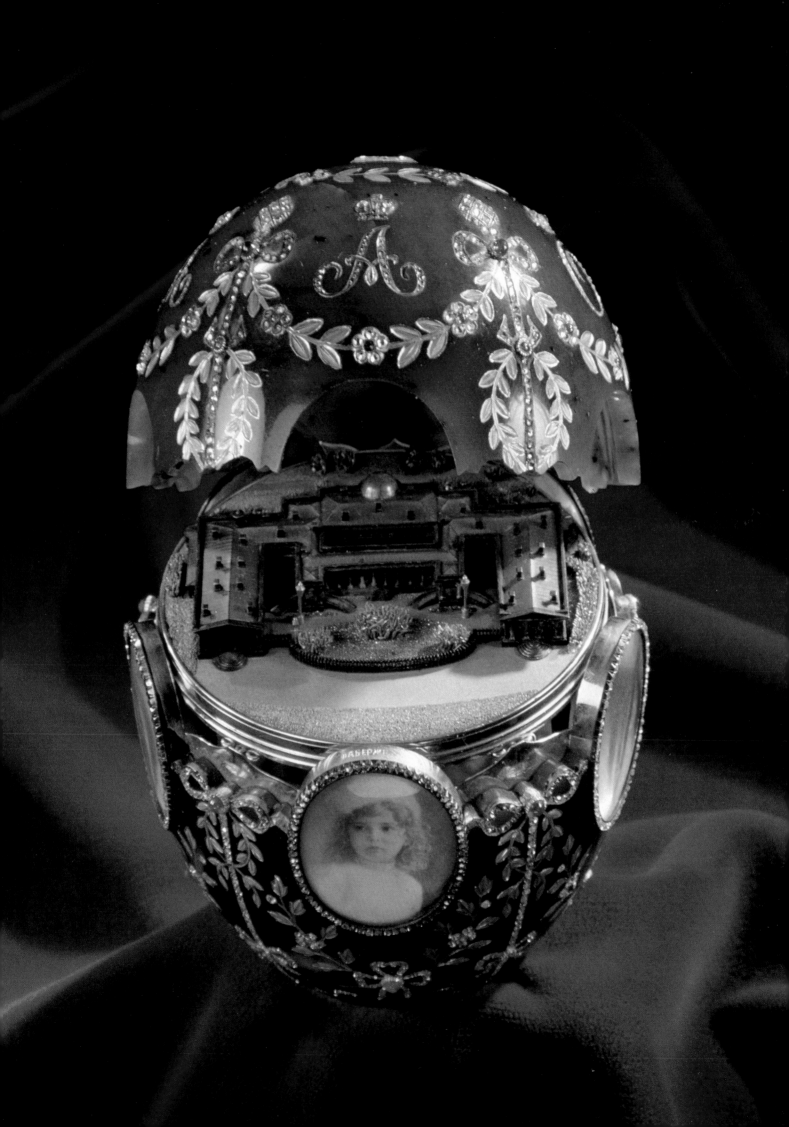

17 STANDART EGG

St. Petersburg, 1909

WORKMASTER: Henrik Wigström

MARKS: FABERGÉ, H. W., 72, kokoshnik

MATERIALS/DIMENSIONS: Gold, diamonds, pearls, lapis lazuli, crystal. Height 6″ (15.3 cm)

TECHNIQUES: Carving, enamel

State Museums of the Moscow Kremlin, inv. no. MR-649/I-2

DESCRIPTION: The crystal egg is horizontally mounted in gold and bears the inscription "Standart 1909" on the edge of the mount.

A gold band, with inlaid leaves of green enamel and small diamonds, lines the perimeter of the egg. The bottom half of the egg is decorated with a vertical gold band with inlaid designs. A crowned eagle of lapis lazuli is perched on either side of the egg; a pear-shaped pearl hangs from each of them. The shaft consists of two lapis lazuli dolphins with intertwined tails. The oval base is of rock crystal with a wide band of white enamel inlaid with laurel garlands and bands of small diamonds with laurel branches in green enamel.

An exact replica in gold of the yacht *Standart* rests inside the egg on an oval base of rock crystal representing the sea.

PROVENANCE: Presented by Czar Nicholas II to his wife, Czarina Alexandra Feodorovna, Easter 1909.

REFERENCES: *The Capital and its Environs* (1916), p. 7, no. 55; Snowman, 1962, pp. 99, 359-60 (ills.); *Armory*, 1964, p. 170; Rodimtseva, 1971, p. 10, no. 6; Donova, 1973, p. 178; Habsburg and Solodkoff, 1979, p. 117, pl. 135; Solodkoff et al., 1984, pp. 64, 95 (ill.), 109; Solodkoff, 1988, pp. 27, 45.

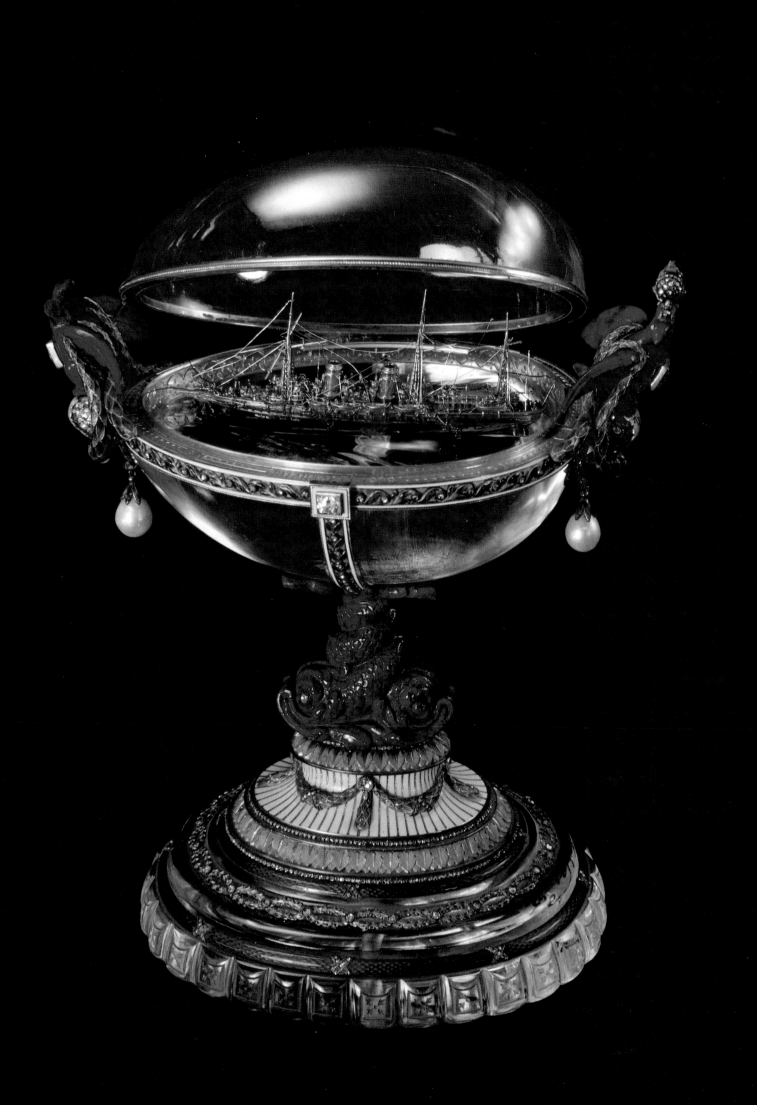

St. Petersburg, 1910

WORKMASTER: Unknown

MARKS: K. FABERGÉ

MATERIALS/DIMENSIONS: Gold, platinum, diamonds, lapis lazuli, rock crystal. Height 6″ (15.5 cm)

TECHNIQUES: Casting, minting, engraving

State Museums of the Moscow Kremlin, inv. no. MR–650/I-3

DESCRIPTION: The egg, containing a gold replica of the monument to Alexander III by Peter Trubetskoy, rests on a rectangular base of lapis lazuli bordered by two rows of roses. The egg is carved out of rock crystal and cloaked with platinum lacework strewn with roses.

A large diamond surmounts the egg and is engraved with the year "1910." The diamond is set in a band of small roses, with a rosette border of platinum acanthus leaves.

The two platinum double-headed eagles on the sides of the egg have diamond crowns. The surface of the egg between the eagles is engraved with branching patterns which are adjoined at the bottom.

The lower hemisphere of the egg serves as a platform for the replica of the monument and is supported by cast platinum cherubs coiled into position on a base of crystal which is shaped like a four-petaled rosette.

PROVENANCE: Presented by Czar Nicholas II to his mother, Dowager Czarina Marie Feodorovna, Easter 1910.

REFERENCES: Snowman, 1962, pp. 100, 364 (ill.); *Armory*, 1964, p. 170; Rodimtseva, 1971, p. 14, no. 6; Donova, 1973, p. 178; Habsburg and Solodkoff, 1979, p. 105, pl. 125; Solodkoff et al., 1984, p. 96 (ill.); Solodkoff, 1988, pp. 27, 43 (ill.).

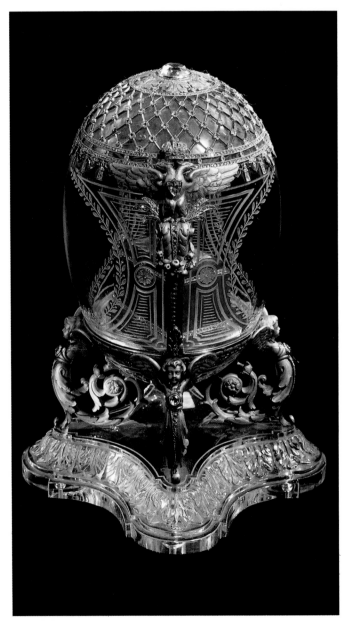

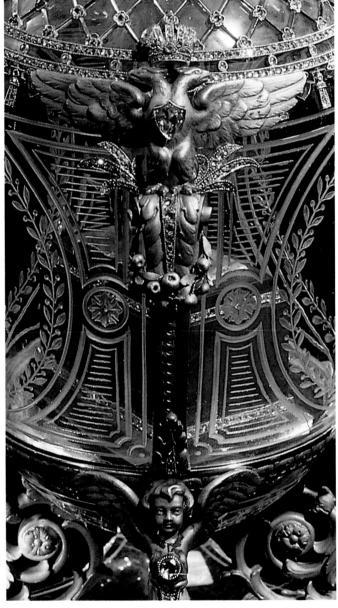

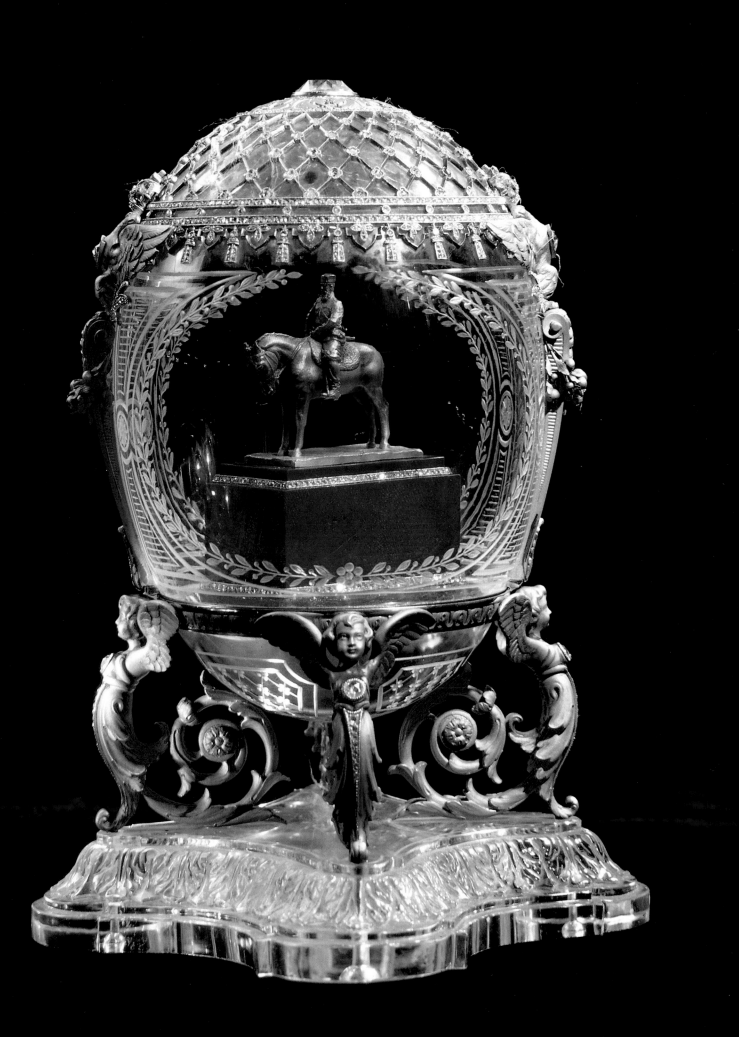

St. Petersburg, 1911

WORKMASTER: Henrik Wigström

MARKS: FABERGÉ, H. W., 72, kokoshnik

MATERIALS/DIMENSIONS: Gold, translucent green enamel, opaque white enamel, opalescent oyster enamel, diamonds, rock crystal, ivory. Height 5¹/₈″ (13.2 cm) (without stand)

TECHNIQUES: Translucent and opaque enamel, opalescent enamel over a guilloché ground, carving, chasing, painting on ivory

The Forbes Magazine Collection, New York

DESCRIPTION: Made to commemorate the fifteenth anniversary of Czar Nicholas II's accession to the throne, the egg is set with miniatures painted by Vassily Zuiev depicting the czar and czarina, their children, and major events of the reign.

PROVENANCE: Presented by Czar Nicholas II to his wife, Czarina Alexandra Feodorovna, Easter 1911; A La Vieille Russie, Inc., New York.

REFERENCES: Forbes, 1979, pp. 1238, 1239, pl. XVIII; Chicago, 1983, p. 17a, no. 97; Fort Worth, 1983, no. 193; Minneapolis, 1983, p. 17a, no. 97; Richmond, 1983, p. 17a, no. 97; Swezey, 1983, pp. 1212, 1213, pls. IV-VI; Detroit, 1984, no. 136; Solodkoff et al., 1984, pp. 96 (ill.), 114-20 (ills.), 121; Kelly, 1985, pp. 2 (ill.), 3; London, 1987; Lugano, 1987; Paris, 1987; Forbes, 1988, p. 39 (ill.); Solodkoff, 1988, pp. 44, 45 (ill.).

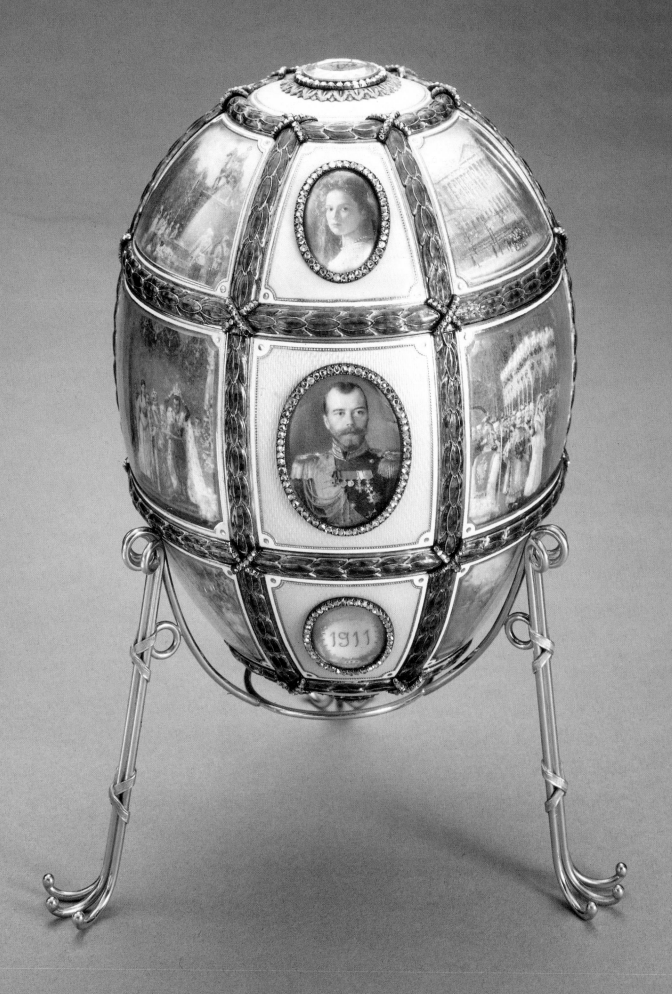

Place unknown, 1911

WORKMASTER: Unknown

MARKS: FABERGÉ, 2990, kmmm11

MATERIALS/DIMENSIONS: Gold, translucent green and opaque white enamel, nephrite, diamonds, citrines, amethysts, rubies, pearls, agate, feathers. Height 11³/₄″ (30 cm) (open)

TECHNIQUES: Translucent and opaque enamel, carving, chasing

The Forbes Magazine Collection, New York

DESCRIPTION: The surprise concealed within the orange tree is a mechanical bird which emerges singing when the right "orange" is turned.

PROVENANCE: Presented by Czar Nicholas II to his mother, Dowager Czarina Marie Feodorovna, Easter 1911; Wartski, London; A.G. Hughes, England; Arthur E. Bradshaw; W. Magalow; Maurice Sandoz, Switzerland; A La Vieille Russie, Inc., New York; Mildred Kaplan, New York.

REFERENCES: Forbes, 1979, pp.1238, 1240, pl. XIX; Fort Worth, 1983, no. 194; Baltimore, 1983-84, no. 77; Detroit, 1984, no. 137; Solodkoff et al., 1984, pp.65, 69, 96, 97 (ill.); Kelly, 1985, pp.20, 21 (ills.); Forbes, 1987, pp. 10 (ill.), 11; London, 1987; Lugano, 1987, pp. 116, 117 (ills.), no. 121; Paris, 1987, pp. 12, 112, 113 (ills.), no. 121; Forbes, 1988, pp.36, 41 (ill.); Solodkoff, 1988, pp.28 (ill.)- 30, 42.

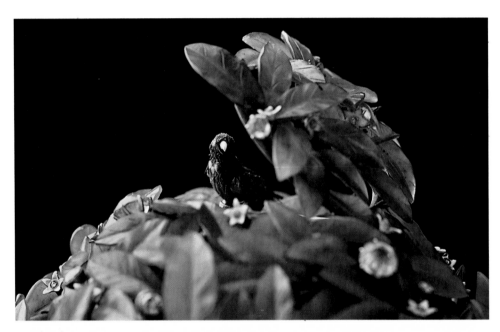

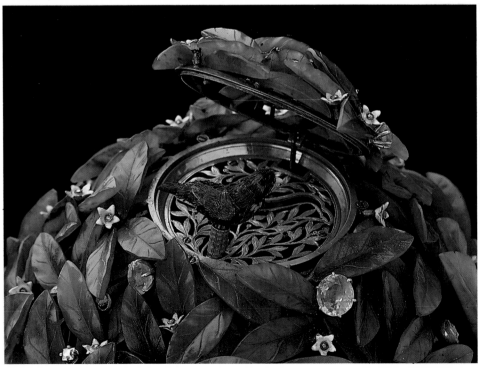

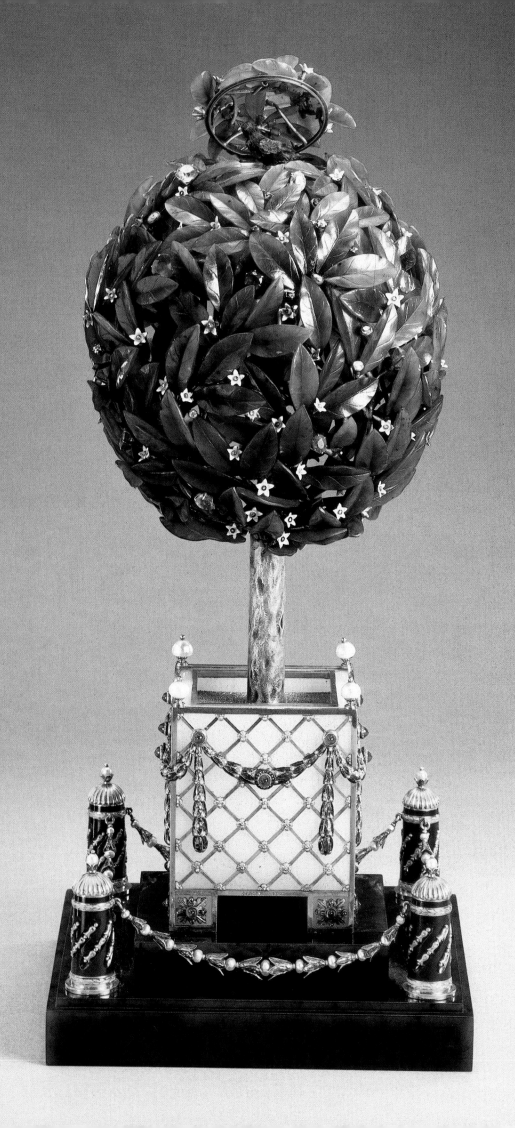

St. Petersburg, 1912

WORKMASTER: Henrik Wigström

MARKS: FABERGÉ, H.W., 56, kokosknik

MATERIALS/DIMENSIONS: Egg: Yellow gold, transparent emerald green and ruby red enamel, rose-cut diamonds, ivory velvet pocket, ivory satin lining. Height 4⅝″ (11.8 cm). Screen: Yellow gold, rose-cut diamonds, platinum, emerald green and opalescent white enamels, gouache on ivory

TECHNIQUES: Translucent enamel over guilloché grounds of sunburst and ondé motifs, casting, chasing

The Matilda Geddings Gray Foundation Collection, New Orleans (New Orleans Museum of Art)

DESCRIPTION: The first Empire-style egg is divided by six vertical and four horizontal double fillets of rose-cut diamonds between which run bands of gold laurel leaves and rosettes on a ground of ruby guilloché enamel. The central register of the egg is formed of six panels bearing alternating applied cast and chased gold appliqués of the Romanov double-headed eagle crest and military trophies. Above and below are secondary registers bearing rosettes of rose-cut diamonds alternating with rondels of red enamel separated by conventionalized leaf and scroll appliqués. A golden diamond-set sunburst centered by a table-cut diamond displaying the crown and cipher of the Dowager Czarina Marie Feodorovna surmounts

the egg. The lower terminal is similarly set with a smaller table-cut diamond displaying the date 1912.

The egg opens at center to reveal a six-panel polygonal folding screen bearing portraits by the court miniaturist Vassily Zuiev, signed and dated 1912, showing members of the czarina's regiments, and inscribed on the backs as follows: "Her Majesty's Eleventh Eastern Siberian Regiment," "Her Majesty's Eleventh Ulan Chuguevski Regiment," "Her Majesty's Second Pskov Dragoon Regiment," "Her Majesty's Naval Guard Regiment," "Her Majesty's Life Guard Kirasirski Regiment," "Her Majesty's Cavalry Guard Regiment."

The panels are enframed in diamond-bound laurel leaves and have hinges of fasces bound with diamonds. The reverse of each panel is enameled in translucent opalescent white over an engine-turned sunburst trimmed in green enamel and centered with a gold-framed green enameled rondel bearing the crowned Cyrillic script cipher of the dowager czarina.

PROVENANCE: Presented by Czar Nicholas II to his mother, Dowager Czarina Marie Feodorovna, Easter 1912; purchased by Hammer Galleries, New York, from the Soviet government, circa 1927.

REFERENCES: New York, 1937, p. 6, no. 8; New York, 1939, ill.; New York, 1951, no. 160, ill., cover; Snowman, 1953, p. 103 (ill.), pls. 370-72; Snowman, 1962/64, p. 103 (ill.); London, 1977, no. O 26; Waterfield and Forbes, 1978, p. 125 (ill.); Habsburg and Solodkoff, 1979, pl. 132; Snowman, 1979, p. 110; Solodkoff et al., 1984, pp. 98-99; Munich, 1986-87, pp. 274, 277 (ill.), no. 542.

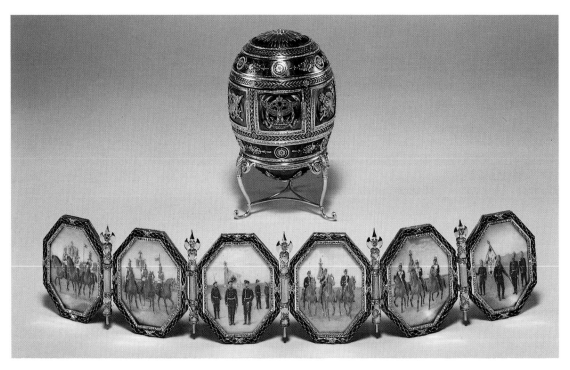

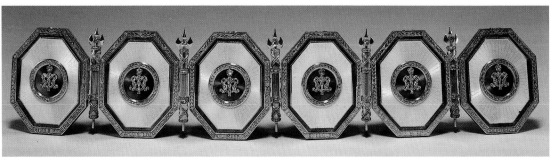

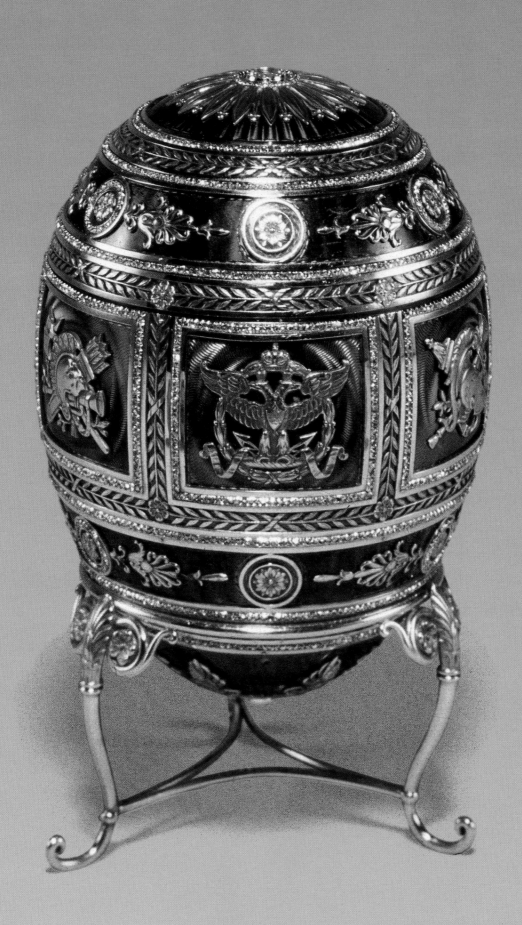

St. Petersburg, 1913

WORKMASTER: Henrik Wigström

MARKS: FABERGÉ, H. W., 1913, 72, kokoshnik

MATERIALS/DIMENSIONS: Gold, silver, steel, diamonds, turquoise, crystal, purpurine, ivory. Height 7^1/$_2$″ (19 cm)

TECHNIQUES: Casting, engraving, painting, gold-plating, enamel

State Museums of the Moscow Kremlin, inv. no. MP-651/I-2

DESCRIPTION: The egg, with eighteen miniature portraits of the Romanov czars, is supported by a shaft in the shape of a three-sided heraldic eagle. The golden egg is covered with white transparent enamel on a guilloché ground. The miniature portraits by Vassily Zuiev, in eighteen round diamond frames, depict members of the Romanov dynasty, from Michael Feodorovich to Nicholas II. The spaces between the portraits contain inlaid patterns of heraldic eagles, crowns, and czar's wreaths. A large diamond bear-ing the dates "1613" and "1913" is secured at the top of the egg, while a large triangular diamond fixed to the bottom end covers the monogram "A. F."

The inside of the egg is lined with opalescent enamel on a guilloché ground. A rotating steel globe of dark blue enamel is secured inside the egg; it shows the territories of Russia in 1613 and 1913, represented in gold.

The base is constructed of purpurine, decorated with small enamel patterns, and secured on three supports cast in the shape of flattened pellets.

PROVENANCE: Presented by Czar Nicholas II to his wife, Czarina Alexandra Feodorovna, Easter 1913.

REFERENCES: *The Capital and its Environs* (1916), p. 4, no. 55; Bainbridge, 1949, p. 72; Snowman, 1962, pp. 104, 373 (ill.); *Armory*, 1964, p. 170; Habsburg and Solodkoff, 1979, p. 105, pl. 121; Solodkoff et al., 1984, p. 99 (ill.); Solodkoff, 1988, p. 45.

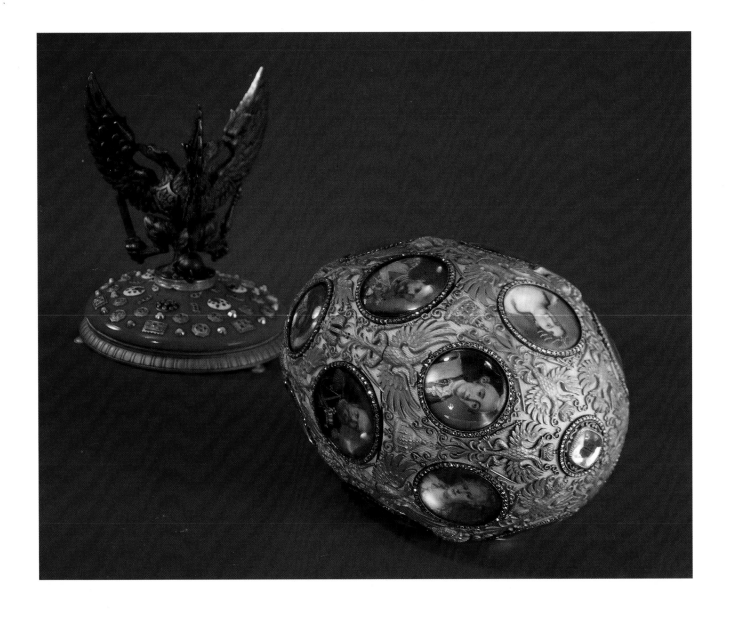

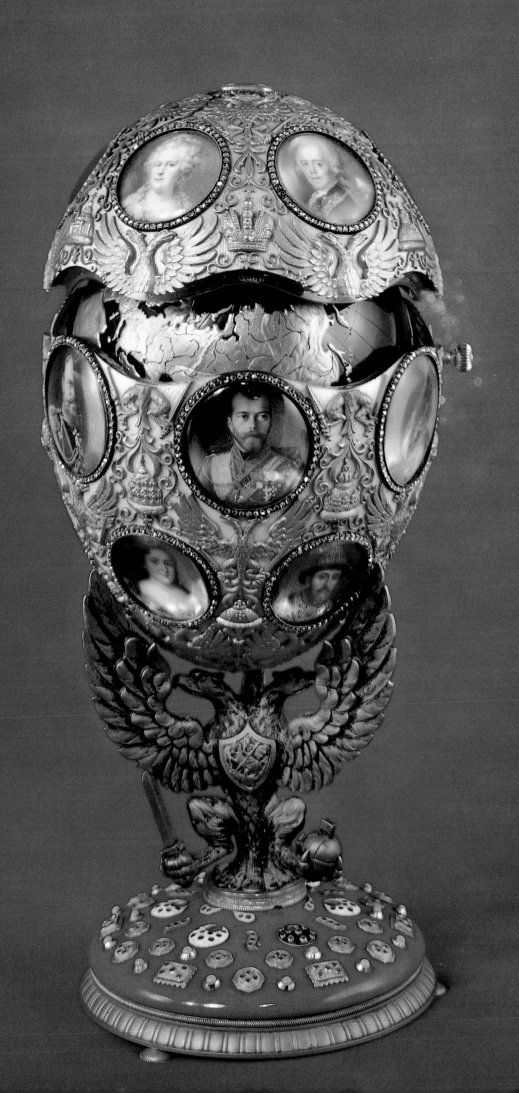

St. Petersburg, 1914

WORKMASTER: August Holmström

MARKS: C. FABERGÉ, G [*sic*] FABERGÉ, AF [initials of Alexandra Feodorovna]

MATERIALS/DIMENSIONS: Yellow gold, platinum, diamonds, rubies, emeralds, topazes, sapphires, garnets, pearls. Height 3⅝″ (9.2 cm)

TECHNIQUES: Opaque enamel, painting on ivory

Her Majesty Queen Elizabeth II

DESCRIPTION: The surprise concealed within, and held in place by two gold clips, consists of a gold, pearl, and translucent green and opaque white enameled pedestal set with diamonds and green garnets and surmounted by a diamond imperial crown, supporting a plaque, on one side of which is shown, painted in pale sepia *grisaille* enamel, the profiles of the five imperial children against a background of engraved vertical parallel lines enameled opalescent rose Pompadour. The reverse is enameled with a pale sepia basket of flowers against a pale green background around which the year 1914 and the names of the children are written in sepia on the opaque ivory enameled border.

The gold surface underneath the pedestal is engraved with a sun-in-splendor design and the name, presumably in error, G. Fabergé, 1914. The egg was designed as a jewel.

PROVENANCE: Presented by Czar Nicholas II to his wife, Czarina Alexandra Feodorovna, Easter 1914; purchased by King George V and Queen Mary, 1934.

REFERENCES: Bainbridge, 1949, pls. 51, 52, 72, 73; Snowman, 1962, pp. 25, 106, pls. LXXIX, LXXX; London, 1977, pp. 49, 50, 52 (ill.); Snowman, 1979, pp. 114, 115 (ill.); Snowman, 1983, pp. 104, 105 (ill.); Solodkoff et al., 1984, pp. 64, 100 (ill.); Munich, 1986-87, pp. 278, 279 (ill.), no. 544; Habsburg, 1987, pp. 278, 279 (ill.); Solodkoff, 1988, pp. 22 (ill.), 34-36, 47, 54-56, 56 (ill.).

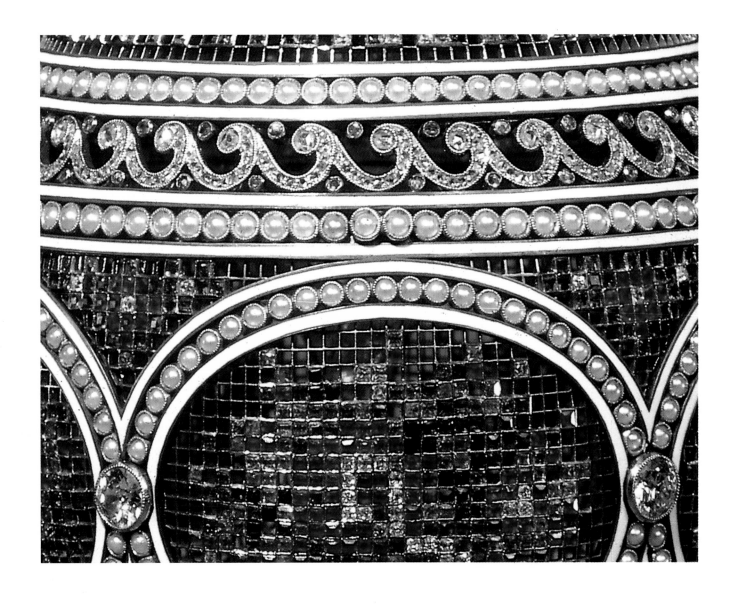

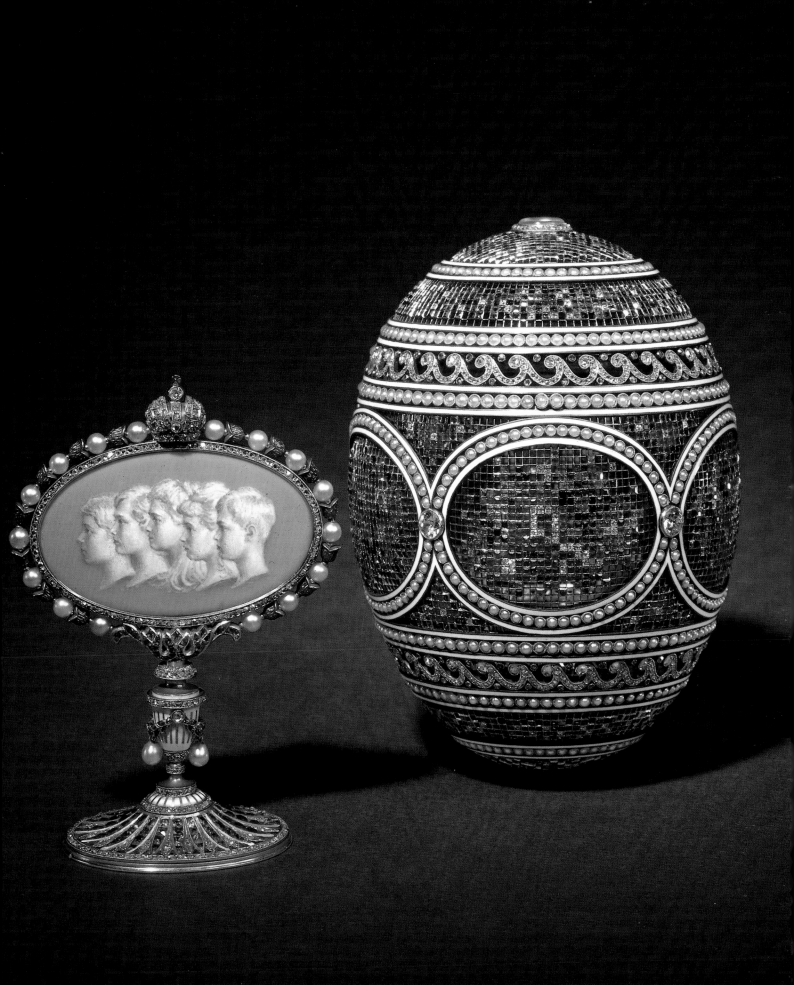

24 Red Cross Egg with Resurrection Triptych

St. Petersburg, 1915

WORKMASTER: Henrik Wigström

MARKS: 72, kokoshnik, lower case alpha in script, H.W., FABERGÉ

MATERIALS/DIMENSIONS: Gold, silver-gilt. Height 3⅜" (8.6 cm)

TECHNIQUES: Enameling on engine-turned ground

The Cleveland Museum of Art, India Early Minshall Collection

DESCRIPTION: In the center of the cross on the back is a circular portrait miniature of Grand Duchess Olga and, on the front, one of Grand Duchess Tatiana, both shown in their Red Cross uniforms. They were daughters of Nicholas II and Alexandra. The front of the egg divides into two quarters when opened, revealing a triptych within. The central scene is the Harrowing of Hell. Christ stands in the center atop the doors of Hell, which he has just broken down. He grasps Adam by his right hand and he is surrounded by patriarchs and prophets. The Harrowing of Hell is the customary method of representing the Resurrection in the Orthodox church. Princess Olga, the founder of Christianity in Russia, is represented on the left wing of the triptych, the Martyr Saint Tatiana on the right. The central scene is painted in natural colors, but with the general golden tonality tradition prescribes for the subject. The wings are decorated in natural colors on gold grounds. According to Snowman, the interior miniatures were executed by Prachov, a miniaturist associated with Fabergé, who specialized in icons. The borders and major inscriptions are in white opaque enamel. The egg is accompanied by its original white velvet case and by a gold stand which was probably not made for it until fairly recently.

According to Snowman, only the mounts of this egg are made of gold and its cost was held to about £200 as a wartime economy measure.

PROVENANCE: Presented by Czar Nicholas II to his wife, Czarina Alexandra Feodorovna, Easter 1915.

REFERENCES: New York, 1951, pp. 27, 31, no. 162; New York, 1961, p. 91, no. 291; Snowman, 1962/64, p. 107, figs. 378-81; San Francisco, 1964, p. 38, no. 144; London, 1977, pp. 76 (ill.), 77, no. M2; Forbes, 1979, pp. 1228-42, pl. XIII; Snowman, 1979, p. 26; Forbes, 1980, p. 68.

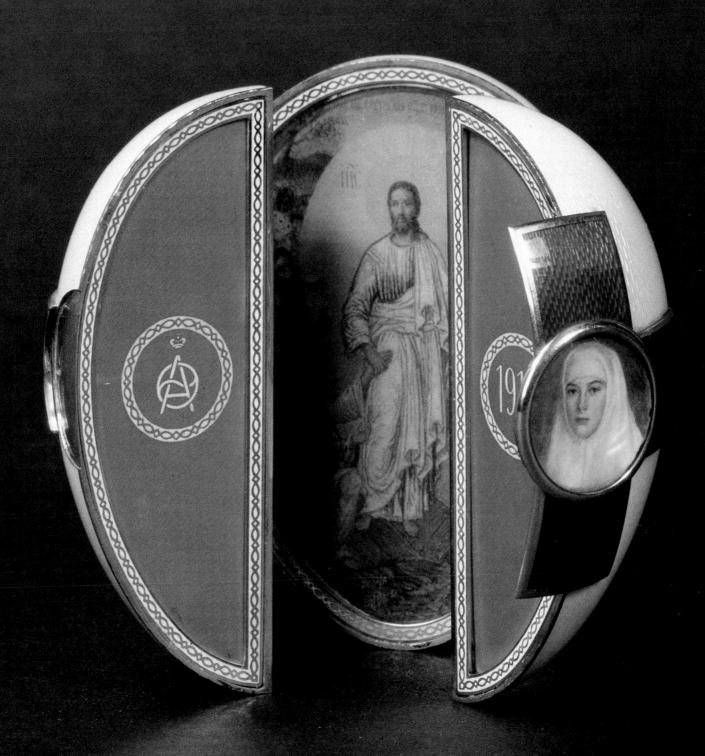

25 STEEL MILITARY EGG

St. Petersburg, 1916

WORKMASTER: Henrik Wigström

MARKS: FABERGÉ, H. W., 72, kokoshnik

MATERIALS/DIMENSIONS: Gold, steel, nephrite. Height 6¹/₂″
(16.7 cm)

TECHNIQUES: Casting, painting

State Museums of the Moscow Kremlin, inv. no. MR-652/I-3

DESCRIPTION: The steel egg, with gold patterns surmounted by a
gold crown, rests on four artillery shells. It is divided into three
sections by two smooth horizontal lines. In the middle section, in
inlaid gold, is an image of George the Conqueror in a diamond-
shaped frame outlined in laurel leaves; the date "1916" encircled
by a laurel wreath; the Russian emblem, consisting of a double-
headed eagle beneath three crowns; and the monogram of Czarina
Alexandra Feodorovna, also encircled by a laurel wreath. The egg
is surmounted by a golden crown surrounded by a gold wreath.

The four steel artillery shells supporting the egg are set on a
dual-level square nephrite base.

A steel easel bearing the monogram of Czarina Alexandra
Feodorovna inserts into the egg. On the easel there is a gold and
white enamel frame displaying the emblem of the Order of
St. George surmounted by a golden crown. The frame encloses a
miniature painting on ivory by Vassily Zuiev depicting Czar
Nicholas II and his son at the Front.

PROVENANCE: Presented by Czar Nicholas II to his wife, Czarina
Alexandra Feodorovna, Easter 1916.

REFERENCES: Bainbridge, 1949, p. 73; Snowman, 1962, pp. 108 ff., 383-84 (ills.);
Armory, 1964, p. 170; Rodimtseva, 1971, p. 16; Donova, 1973, p. 178; Habsburg
and Solodkoff, 1979, pp. 158, no. 56, 165 (ill.); Solodkoff et al., 1984, p. 107 (ill.);
Solodkoff, 1988, pp. 36, 45.

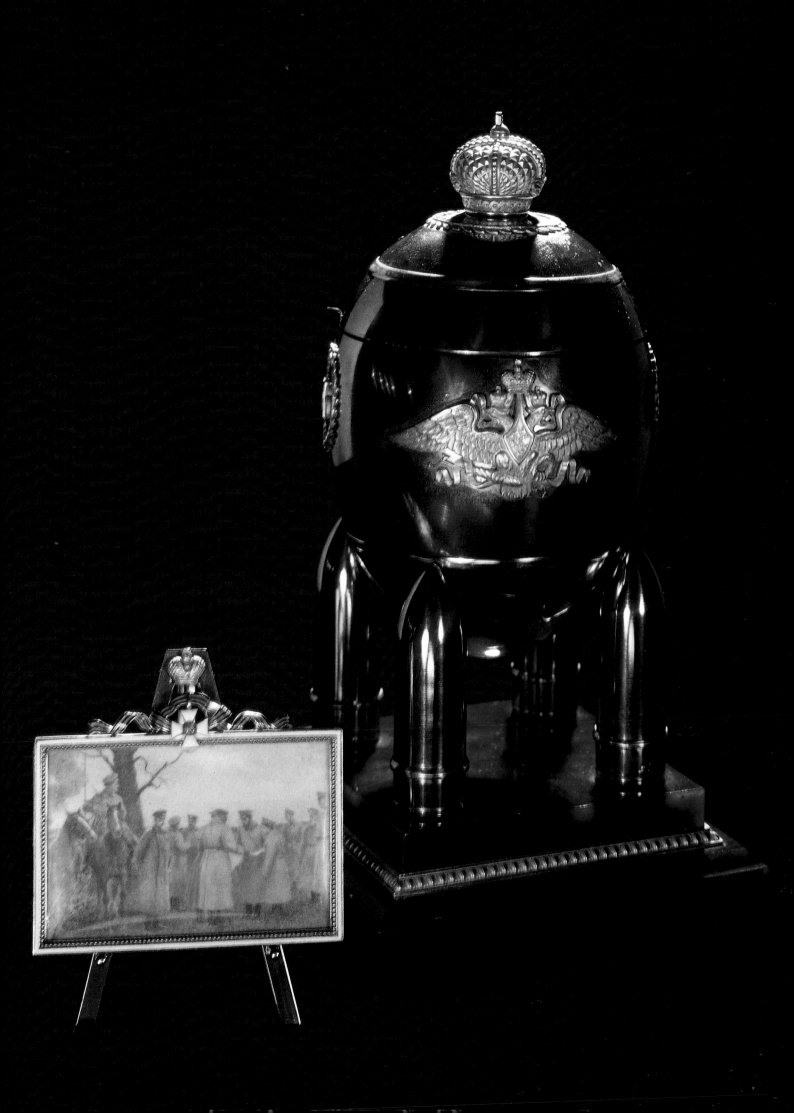

Place unknown, 1916

WORKMASTER: Unknown

MARKS: FABERGÉ

MATERIALS/DIMENSIONS: Silver, gold, translucent orange, opalescent white, opaque rose, pale green, white, and black enamel, rock crystal, ivory. Height 3¹/₂″ (9 cm) (without stand)

TECHNIQUES: Opalescent enamel over a silver ground, carving, painting on ivory

The Forbes Magazine Collection, New York

DESCRIPTION: Less extravagant than its predecessors, this austere silver egg commemorates the presentation of the Cross of the Order of St. George to Czar Nicholas II. A miniature of the czar is revealed behind the badge of the Order when a small button below the badge is depressed. A miniature of the czarevitch is similarly revealed from behind a silver St. George medal when a second button is pushed. The last in the series of Easter eggs to be delivered to the imperial family, it was the only egg to leave Russia in the possession of its original recipient, Dowager Czarina Marie Feodorovna.

PROVENANCE: Presented by Czar Nicholas II to his mother, Dowager Czarina Marie Feodorovna, Easter 1916; her daughter Grand Duchess Xenia Alexandrovna; her son Prince Vassily Romanov; Sotheby's, circa 1961-62; Fabergé, Inc.; A La Vieille Russie, Inc., New York.

REFERENCES: London, 1935, p. 108 (ill.), no. 560; London, 1977, p. 74 (ill.), no. L12; Boston, 1979; Forbes, 1979, p. 1238, pl. xx; Chicago, 1983, p. 17, no. 98; Coburn, 1983; Fort Worth, 1983, no. 195; Minneapolis, 1983, p. 17, no. 98; Richmond, 1983, p. 17, no. 98; Solodkoff, 1983, p. 66; Detroit, 1984, no. 138; Solodkoff et al., 1984, pp. 108-09 (ills.); Kelly, 1985, p. 14; Solodkoff, 1988, pp. 36, 38 (ill.), 42.

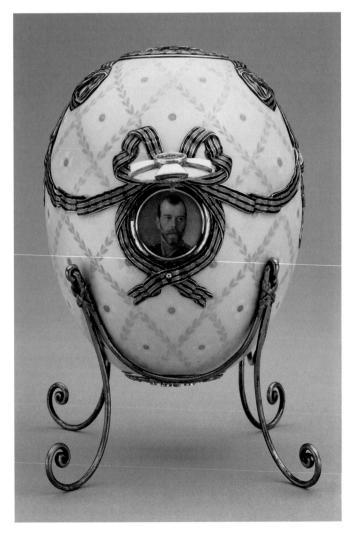
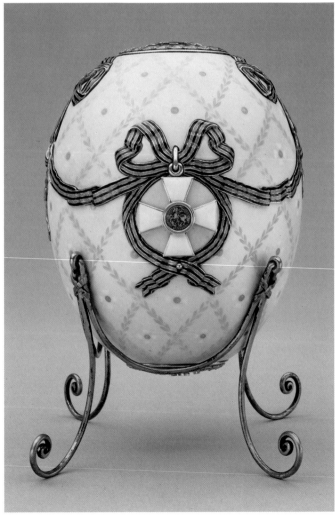

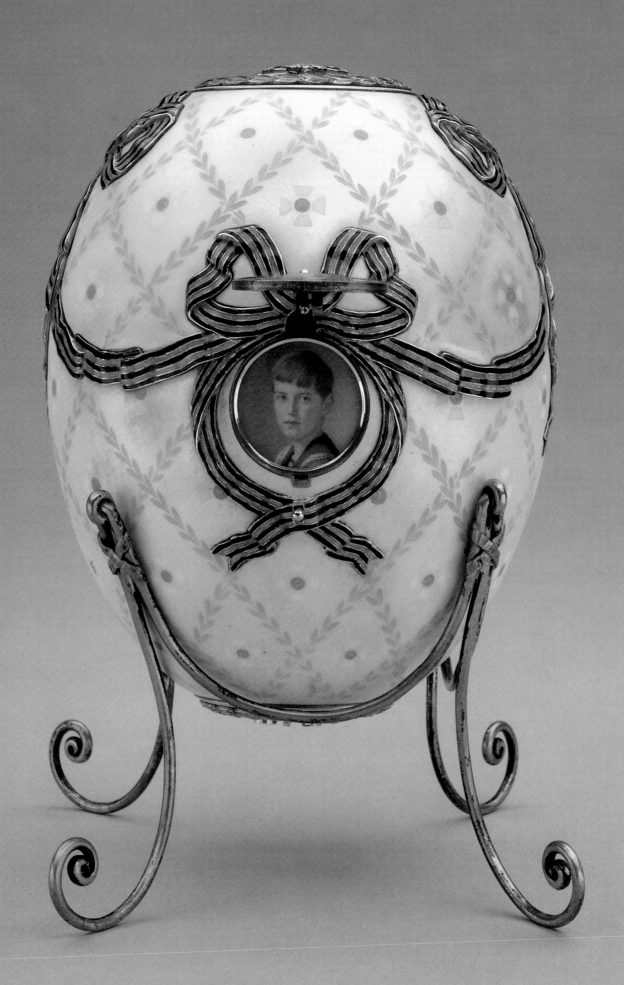

27 CORONATION BOX

St. Petersburg, before 1899

WORKMASTER: August Holmström

MARKS: FABERGÉ, AH, 56, crossed anchors and scepter, 1067 [inv. no.]

MATERIALS/DIMENSIONS: Two-color gold, translucent yellow enamel, opalescent oyster enamel, opaque black enamel, diamonds. Height 3³/₄" (9.5 cm)

TECHNIQUES: Translucent and opalescent enamel over a guilloché ground, chasing

The Forbes Magazine Collection, New York

DESCRIPTION: Similar in design to the Coronation Egg, this box was Czarina Alexandra Feodorovna's gift to Czar Nicholas II on Easter 1897, when her husband presented her with the egg (plate 7; no. 14, p. 98). The double-headed eagles of the Romanov family crest decorate the lid of the box, which bears Czar Nicholas II's crowned monogram set in diamonds.

PROVENANCE: Presented by Czarina Alexandra Feodorovna to her husband, Czar Nicholas II, Easter 1897; Herr Bomm, Vienna; Sidney Hill, Berry-Hill Galleries, London and New York; Wartski, London; Arthur E. Bradshaw; Lansdell K. Christie, Long Island; A La Vieille Russie, Inc., New York.

REFERENCES: Brown, 1979, pp. 64 (ill.), 65; Habsburg and Solodkoff, 1979, pp. 126, 128 (ill.); Feifer, 1983, p. 95 (ill.); Fort Worth, 1983, no. 26; Swezey, 1983, pp. 1210, 1211, pl. III; Detroit, 1984, no. 37; Solodkoff et al., 1984, pp. 25, 27, 173 (ill.); Munich, 1986-87, p. 255, no. 513; Forbes, 1987; London, 1987, p. 16 (ill.); Lugano, 1987, pp. 94, 95 (ills.), no. 95; Paris, 1987, pp. 90, 91 (ills.), no. 95.

28 LILIES OF THE VALLEY CIGARETTE CASE

St. Petersburg, 1898

WORKMASTER: Michael Perchin

MARKS: FABERGÉ, M. P, 88, crossed anchors and scepter

MATERIALS/DIMENSIONS: Cork, gold, silver-gilt, diamonds, ivory. Height 3" (7.7 cm)

TECHNIQUES: Engraving, painting on ivory

The Forbes Magazine Collection, New York

DESCRIPTION: This unusual cork box was Czarina Alexandra Feodorovna's gift to her husband in 1898, the year Czar Nicholas II presented her the Lilies of the Valley Egg (plate 8; no. 15, p. 99). Like the egg, the cigarette case features two miniatures of the czar and czarina's eldest daughters, Grand Duchesses Olga and Tatiana, painted in this instance by court miniaturist Konstantin Makovksy. The inner lid of the case is inscribed in English in the czarina's hand, "In remembrance/of Moscow/August 16th 1898/fr. your loving/Alix." Prior to her marriage to Czar Nicholas II, the czarina was Princess Alix of Hesse-Darmstadt.

PROVENANCE: Presented by Czarina Alexandra Feodorovna to her husband, Czar Nicholas II, 1898; sold to anonymous buyer, Arne Bruun Rasmussen, Copenhagen, April 16, 1985, Lot 2311; A La Vieille Russie, Inc., New York.

REFERENCES: Copenhagen, Arne Bruun Rasmussen, Apr. 16, 1985, pp. 526, 535 (ill.), no. 2311; Forbes, 1986, pp. 56, 57.

29 MEDAL TO COMMEMORATE THE PARIS WORLD EXPOSITION OF 1900

Paris, 1900

WORKMASTER: Jean Chaplain

MATERIALS/DIMENSIONS: Bronze. Diameter 2¹/₂″ (6.4 cm)

TECHNIQUE: Minting

State Museums of the Moscow Kremlin, inv. no. OM-1881

DESCRIPTION: The medal bears a symbolic portrait of a woman wearing a Phrygian cap on the obverse. On the reverse appear a winged Victory and a young man with a torch soaring above the city. The medal is inscribed "Exposition Universelle Internationale" and also gives the name of the recipient of the award, "M. Perkhine."

PROVENANCE: Gift from Georgi S. Aristov, great grandson of Michael Perchin, 1974.

30 SEAL

St. Petersburg, 1904-17

WORKMASTER: Fedor Afanassiev

MARKS: ФА, 14855 [inv. no.]

MATERIALS/DIMENSIONS: Gold, bowenite, translucent peach-colored enamel, agate. Height 1⁷/₁₆″ (3.6 cm)

TECHNIQUES: Casting, chasing, engraving, enamel over guilloché ground

Private collection, London

DESCRIPTION: The seal has an egg-shaped bowenite handle and a flared gold stem, with peach-colored guilloché enameling, that terminates in a base encircled by a chased green gold laurel-leaf design. The agate matrix is engraved with the crowned monogram AH of Czarevitch Alexis Nicholaievich, whose personal seal this was.

PROVENANCE: Acquired indirectly from a member of the imperial family, 1965.

REFERENCES: London, 1977, p. 70, no. K32 (ills.); Snowman, 1979, p. 43 (ills.); Munich, 1986-87, p. 144, no. 127; Habsburg, 1987, p. 144, no. 127 (ill.).

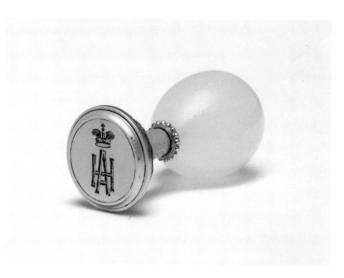

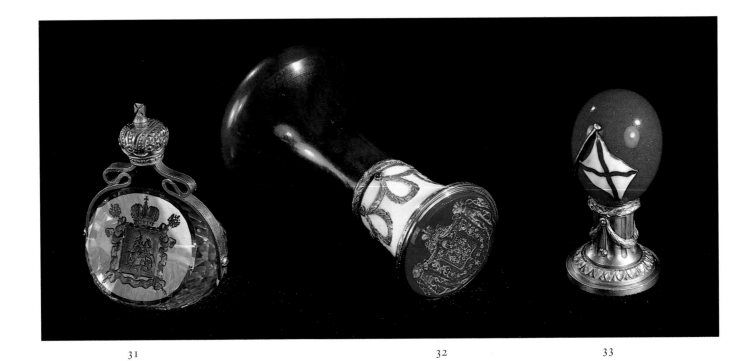

31 32 33

31 SEAL

St. Petersburg, late 19th century (before 1889)

WORKMASTER: Wilhelm Reimer

MARKS: W. R, 56, crossed anchors and scepter

MATERIALS/DIMENSIONS: Gold, topaz. Height 2″ (5 cm)

TECHNIQUES: Casting, carving

State Museums of the Moscow Kremlin, inv. no. OM-2160

DESCRIPTION: The seal on a golden triangle of topaz bears the emblems and names of the estates Ilinskoe and Usovo in the environs of Moscow in the oval section with a gold revolving handle. It belonged to Grand Duke Sergei Alexandrovich, Governor of Moscow from 1857 to 1905.

PROVENANCE: Acquired in 1926 from the Treasury of the Moscow Jewelers Society.

32 SEAL

St. Petersburg, 1896-1903

WORKMASTER: Henrik Wigström

MARKS: H. W., Y. L. [Initials of inspector Yakova Lyapunova of St. Petersburg Standard Board], 72, kokoshnik

MATERIALS/DIMENSIONS: Gold, nephrite, rubies. Height 3¹/₄″ (8.3 cm)

TECHNIQUES: Casting, minting, carving, enamel

State Museums of the Moscow Kremlin, inv. no. OM-2158

DESCRIPTION: The seal, made of carnelian, bears a small emblem of the Russian empire which is framed in gold with a nephrite handle. It is decorated with six rubies, white enamel, and garlands made from tinted gold.

PROVENANCE: Aquired from the imperial estate between 1920 and 1923.

33 SEAL

St. Petersburg, early 20th century

WORKMASTER: Unknown

MATERIALS/DIMENSIONS: Silver, purpurine. Height 2″ (5 cm)

TECHNIQUES: Casting, carving, enamel

State Museums of the Moscow Kremlin, inv. no. OM-2150

DESCRIPTION: The small silver seal is named after the imperial yacht *Standart* and has an egg-shaped purpurine handle bearing the white and blue banner of Saint Andrew.

PROVENANCE: Acquired from the imperial estate in a case made by C. Fabergé Company between 1920 and 1923.

Original cases for the Spring Flowers Egg (plate 9), ▷
the Renaissance Egg (plate 4), and three other Fabergé Easter eggs.
The Forbes Magazine Collection, New York

The Imperial Eggs: A Catalogue

The publishers wish to acknowledge the assistance of
Alexander von Solodkoff in the preparation of this catalogue

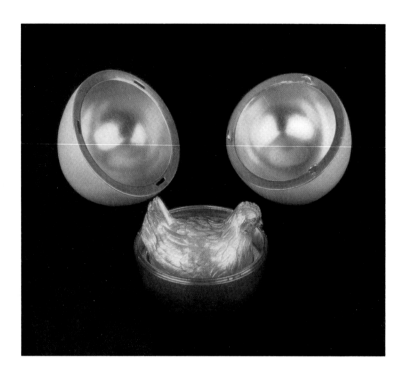

1 First Imperial Egg
 1885
 Erik Kollin (?)
 Gold, *quatre-couleur* gold, rubies, white enamel
 Length 2¹/₂″ (6.4 cm)
 Surprise: Hen
 The Forbes Magazine Collection, New York
 Presented by Czar Alexander III to his wife,
 Czarina Marie Feodorovna

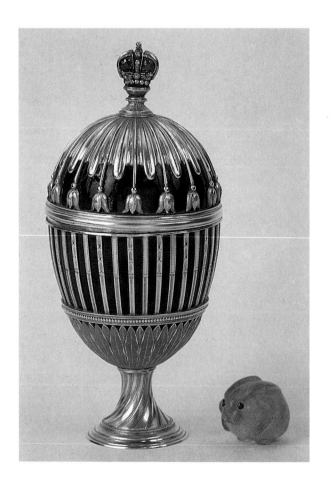

2 Egg with Blue Enamel Ribbing
 1885-91
 Michael Perchin
 Green, red, and yellow gold, sapphire blue enamel,
 sapphires, diamonds, agate, rubies
 Height 4³/₈″ (11 cm)
 Surprise: Rabbit
 Private collection
 Supposed to have been presented by Czar Alex-
 ander III to his wife, Czarina Marie Feodorovna,
 but more probably presented to the czarevitch
 Plate 1

3 Resurrection Egg
1885-90 (1886?)
Michael Perchin
Rock crystal, gold, red, white, blue, green, yellow,
and beige enamel, diamonds, pearls
Height 3⁷/₈" (9.8 cm)
Surprise: Miniature sculpture of the Resurrection
The Forbes Magazine Collection, New York
Presented by Czar Alexander III to his wife,
Czarina Marie Feodorovna

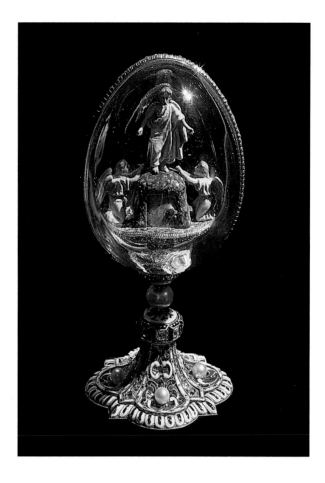

4 Danish Jubilee Egg
1888 or 1906
Workmaster unknown
Miniatures by Konstantin Krijitski
Gold, white and blue enamel
Dimensions unknown
Surprise: Pedestal supporting miniature of King
Christian IX of Denmark
Whereabouts unknown
Presented by Czar Alexander III or Czar Nicholas II
to (Dowager) Czarina Marie Feodorovna

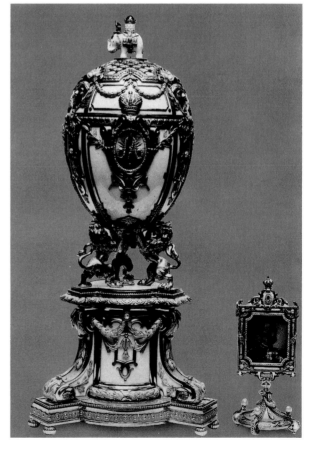

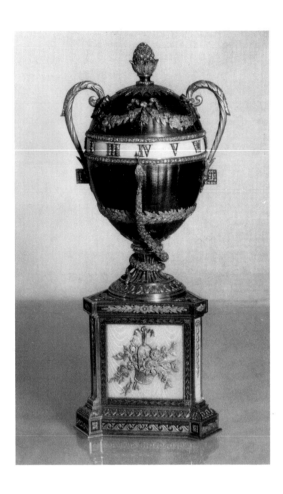

5 Blue Serpent Clock Egg
 1889
 Michael Perchin
 Gold, translucent royal blue and opalescent white
 enamel, diamonds
 Height 7^1/$_4$″ (18.5 cm)
 Surprise: None
 Private collection, Switzerland
 Presented by Czar Alexander III to his wife,
 Czarina Marie Feodorovna

6 Azova Egg
 1891
 Michael Perchin and Yuri Nicolai
 Gold, platinum, diamond, rubies, heliotrope,
 aquamarine, velvet
 Length 3^5/$_8$″ (9.3 cm)
 Surprise: Replica of cruiser *Pamiat Azova*
 Armory Museum, State Museums of the Moscow
 Kremlin
 Presented by Czar Alexander III to his wife,
 Czarina Marie Feodorovna
 Plate 2

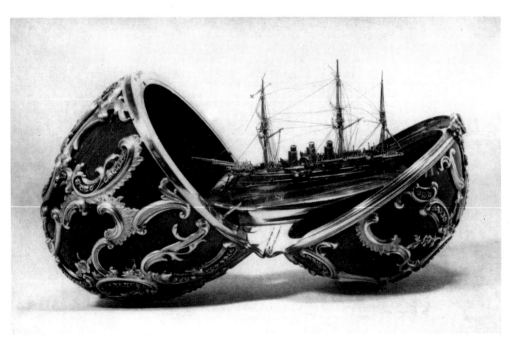

7 Silver Anniversary Egg
 1892
 Michael Perchin
 Gold, blue enamel, rose-cut diamonds
 Height 3¹/₄″ (8.3 cm)
 Surprise: Lost
 Hillwood Museum, Washington, D.C., Marjorie
 M. Post Collection
 Presented by Czar Alexander III to his wife,
 Czarina Marie Feodorovna

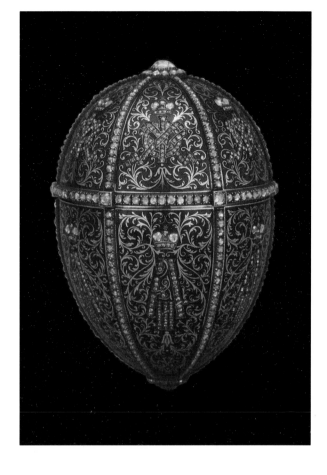

8 Caucasus Egg
 1893
 Michael Perchin
 Miniatures by Konstantin Krijitski
 Yellow and *quatre-couleur* gold, silver, platinum,
 transparent ruby enamel, rose-cut and table-cut
 diamonds, pearls, ivory, watercolor (?)
 Height 3⁵/₈″ (9.2 cm)
 Surprise: Window covers open to reveal minia-
 tures of imperial hunting lodge Abastuman
 The Matilda Geddings Gray Foundation, New
 Orleans (New Orleans Museum of Art)
 Presented by Czar Alexander III to his wife,
 Czarina Marie Feodorovna
 Plate 3

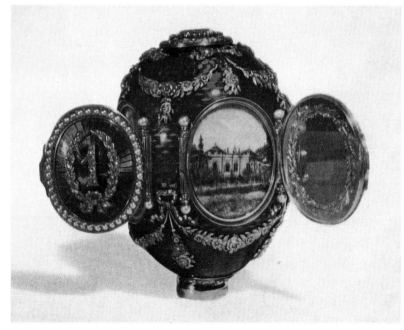

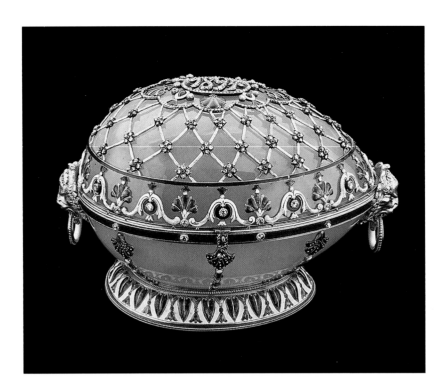

9 Renaissance Egg
 1894
 Michael Perchin
 White agate, gold, translucent green, red, and
 blue enamel, opaque black and white enamel,
 diamonds, rubies
 Height 5¹/₂″ (14 cm)
 Surprise: Unknown
 The Forbes Magazine Collection, New York
 Presented by Czar Alexander III to his wife,
 Czarina Marie Feodorovna
 Plate 4

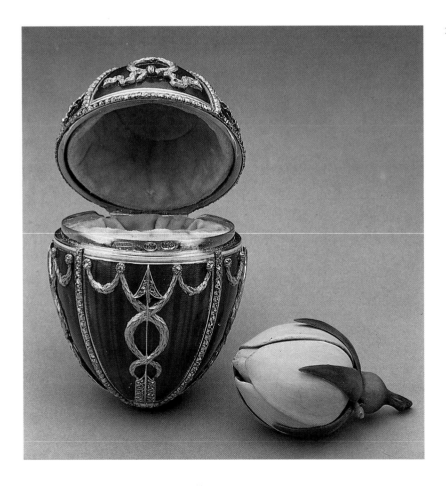

10 Rosebud Egg
 1895
 Michael Perchin
 Gold, *quatre-couleur* gold, translucent red,
 opaque white, green, and yellow enamel, dia-
 monds, velvet
 Height 2⁵/₈″ (6.8 cm)
 Surprise: Rosebud containing replica of
 imperial crown and ruby egg pendant
 (both lost)
 The Forbes Magazine Collection, New York
 Presented by Czar Nicholas II to his wife,
 Czarina Alexandra Feodorovna
 Plate 5

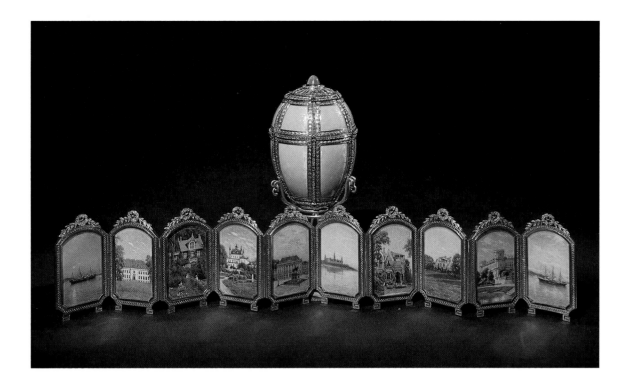

11 Danish Palace Egg
 1895
 Michael Perchin
 Miniatures by Konstantin Krijitski
 Green and rose gold, *quatre-couleur* gold, rose-cut
 diamonds, emerald, rosettes, sapphire, mauve
 opalescent enamel over engine-turned ground,
 velvet, mother-of-pearl, watercolor (?)
 Height 4″ (10.1 cm)
 Surprise: Ten-panel folding screen bearing minia-
 tures of the imperial yachts *Tsarevna* and *Polar Star*
 and of castles and palaces in Denmark and Russia
 The Matilda Geddings Gray Foundation, New
 Orleans (New Orleans Museum of Art)
 Presented by Czar Nicholas II to his mother,
 Dowager Czarina Marie Feodorovna
 Plate 6

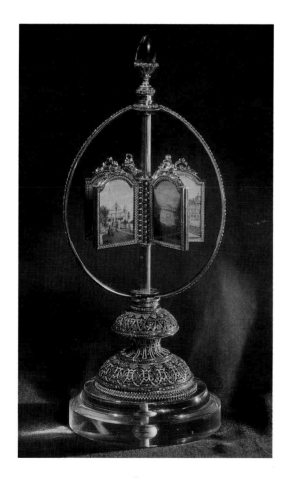

12 Egg with Revolving Miniatures
 1896 (?)
 Michael Perchin
 Miniatures by Johannes Zehngraf
 Rock crystal, gold, translucent emerald green
 enamel, rose-cut diamonds, emerald
 Height 10″ (25.4 cm)
 Surprise: Revolving miniatures with views of
 imperial residences
 Virginia Museum of Fine Arts, Richmond, Lillian
 T. Pratt Collection
 Presented by Czar Nicholas II to his wife,
 Czarina Alexandra Feodorovna

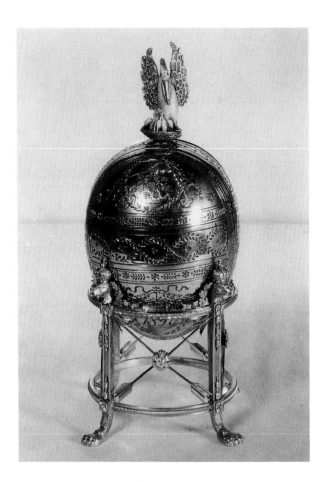

13 Pelican Egg
 1897
 Michael Perchin
 Gold, opalescent white enamel, diamonds, ivory,
 pearls
 Height 4″ (10.2 cm)
 Surprise: Seven-panel folding screen bearing
 miniatures of institutions of which the Dowager
 Czarina was patroness
 Virginia Museum of Fine Arts, Richmond, Lillian
 T. Pratt Collection
 Presented by Czar Nicholas II to his mother,
 Dowager Czarina Marie Feodorovna

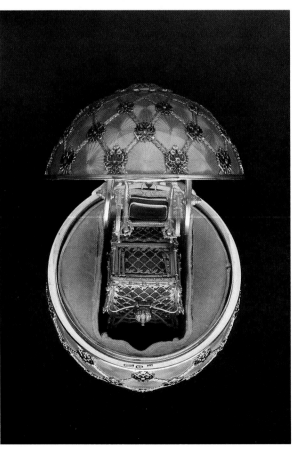

14 Coronation Egg
 1897
 Michael Perchin and Henrik Wigström
 Coach by George Stein
 Gold, *quatre-couleur* gold, platinum, translucent
 lime yellow, opaque black, and strawberry red
 enamel, diamonds, rubies, rock crystal, velvet
 Height 5″ (12.6 cm)
 Surprise: Replica of coach used at imperial coro-
 nation in 1896 (diamond egg inside coach lost)
 The Forbes Magazine Collection, New York
 Presented by Czar Nicholas II to his wife,
 Czarina Alexandra Feodorovna
 Plate 7

15 Lilies of the Valley Egg
 1898
 Michael Perchin
 Miniatures by Johannes Zehngraf
 Gold, translucent pink and green enamel, dia-
 monds, rubies, pearls, rock crystal, ivory
 Height 7⅞" (20 cm) (open)
 Surprise: Miniatures of czar and his two eldest
 daughters emerge when pearl "button" is turned
 The Forbes Magazine Collection, New York
 Presented by Czar Nicholas II to his mother,
 Dowager Czarina Marie Feodorovna
 Plate 8

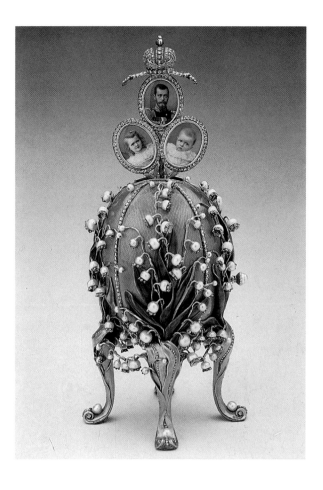

16 Spring Flowers Egg
 Before 1899
 Michael Perchin
 Gold, *quatre-couleur* gold, platinum, translucent
 strawberry red and green enamel, diamonds,
 bowenite, white chalcedony, demantoids
 Height 3¼" (8.3 cm)
 Surprise: Bouquet of anemonies in basket
 The Forbes Magazine Collection, New York
 Presented by Czar Alexander III to his wife,
 Czarina Marie Feodorovna
 Plate 9

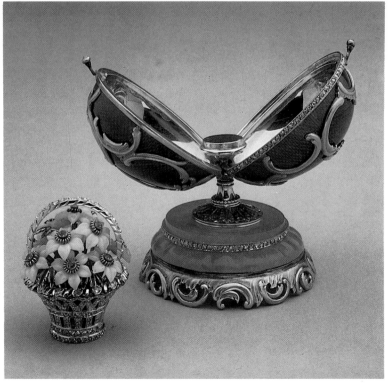

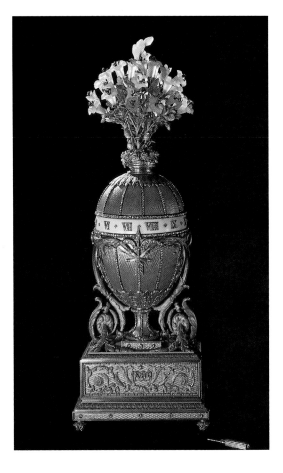

17 Madonna Lily Egg
 1899
 Michael Perchin
 Gold, platinum, silver, rosettes, onyx
 Height 10⅝″ (27 cm)
 Surprise: None
 Armory Museum, State Museums of the Moscow
 Kremlin
 Presented by Czar Nicholas II to his wife,
 Czarina Alexandra Feodorovna
 Plate 10

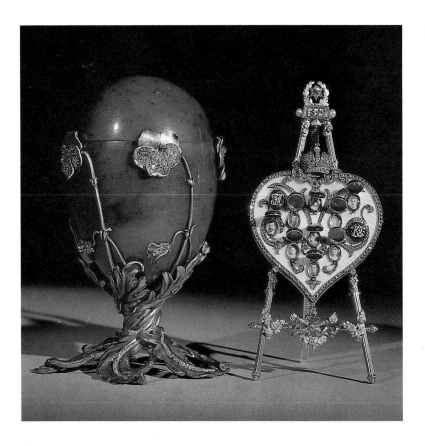

18 Pansy Egg
 1899
 Michael Perchin
 Gold, white, red, green, and violet enamel,
 diamonds, pearls, nephrite, silver-gilt
 Height 5¾″ (14.6 cm)
 Surprise: Easel supporting a heart whose oval
 covers open to reveal miniatures of members of
 the imperial family
 Private collection, U.S.A.
 Plate 11

19 Cuckoo Egg
 1900
 Michael Perchin
 Quatre-couleur gold, translucent violet and green
 enamel, opalescent white and oyster enamel,
 opaque lilac enamel, diamonds, rubies, pearls,
 feathers
 Height 8″ (20.3 cm) (open)
 Surprise: Cockerel emerges crowing and flapping
 its wings when a button is pressed
 The Forbes Magazine Collection, New York
 Presented by Czar Nicholas II to his mother,
 Dowager Czarina Marie Feodorovna
 Plate 12

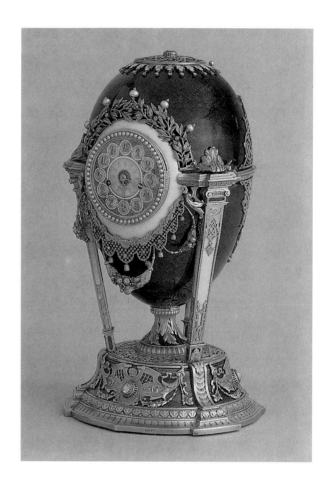

20 Trans-Siberian Railway Egg
 1900
 Michael Perchin
 Gold, platinum, tinted gold, silver, rosettes, rubies,
 onyx, crystal
 Height 10¼″ (26 cm)
 Surprise: Working model of first Trans-Siberian
 Railway train
 Armory Museum, State Museums of the Moscow
 Kremlin
 Presented by Czar Nicholas II to his wife,
 Czarina Alexandra Feodorovna
 Plate 13

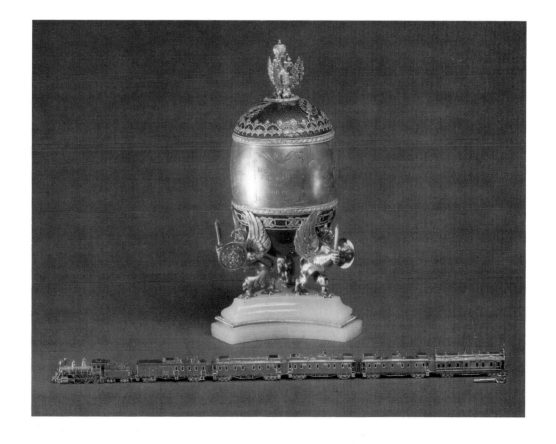

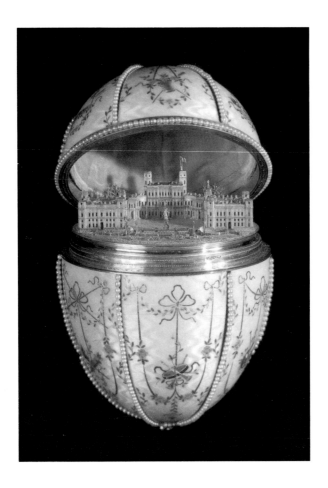

21 Gatchina Palace Egg
 1902
 Michael Perchin
 Gold, *quatre-couleur* gold, green, red, yellow,
 and white enamel, pearls
 Height 5″ (12.7 cm)
 Surprise: Replica of Gatchina Palace
 The Walters Art Gallery, Baltimore
 Presented by Czar Nicholas II to his mother,
 Dowager Czarina Marie Feodorovna

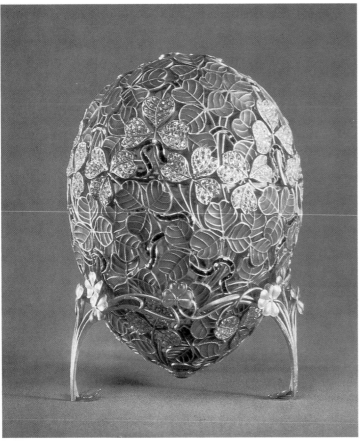

22 Clover Egg
 1902
 Michael Perchin
 Gold, green enamel, diamonds, rubies
 Height 3³/₈″ (8.5 cm)
 Surprise: Lost
 Armory Museum, State Museums of the Moscow
 Kremlin
 Presented by Czar Nicholas II to his wife,
 Czarina Alexandra Feodorovna

23 Peter the Great Egg
1903
Michael Perchin
Miniatures by Vassily Zuiev
Gold, *quatre-couleur* gold, diamonds, rubies,
sapphire, translucent yellow and opaque white
enamel
Height 4¹/₄″ (11 cm)
Surprise: Replica of monument to Peter the Great
by Etienne-Maurice Falconet
Virginia Museum of Fine Arts, Richmond,
Lillian T. Pratt Collection
Presented by Czar Nicholas II to his wife,
Czarina Alexandra Feodorovna

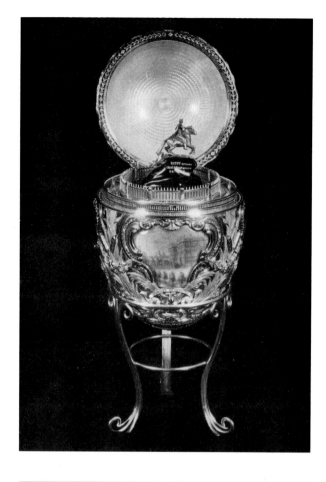

24 Alexander III Commemorative Egg
1904
Workmaster unknown
Gold, platinum, opaque white enamel, diamonds,
lapis lazuli
Height 3³/₄″ (9.5 cm)
Surprise: Unknown
Whereabouts unknown
Presented by Czar Nicholas II to his wife,
Czarina Alexandra Feodorovna

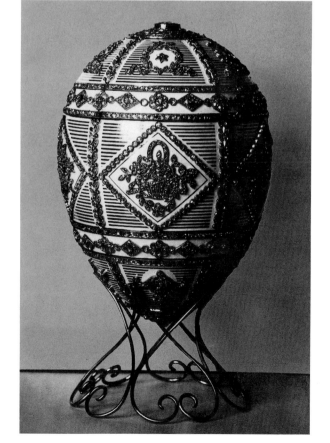

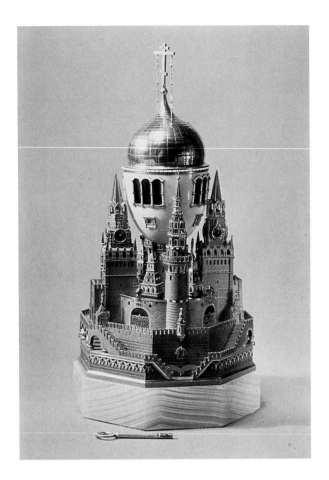

25 Uspensky Cathedral Egg
 1904
 Workmaster unknown
 Onyx, *quatre-couleur* gold, white and green enamel
 Height 14¹/₂″ (37 cm)
 Surprise: Musical automaton
 Armory Museum, State Museums of the Moscow
 Kremlin
 Presented by Czar Nicholas II to his wife,
 Czarina Alexandra Feodorovna

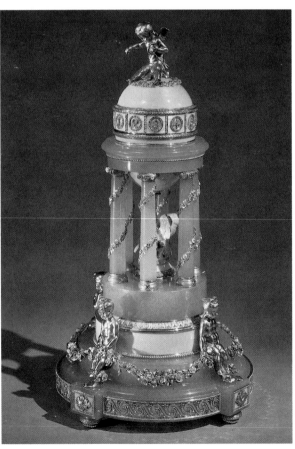

26 Colonnade Egg
 Probably 1905
 Henrik Wigström
 Bowenite, *quatre-couleur* gold, rose-cut diamonds,
 silver-gilt, platinum
 Height 11¹/₄″ (28.6 cm)
 Surprise: None
 Her Majesty Queen Elizabeth II
 Presented by Czar Nicholas II to his wife,
 Czarina Alexandra Feodorovna
 Plate 14

27 Egg with Love Trophies
1905 or 1910
Henrik Wigström
Quatre-couleur gold, translucent pale blue and
green enamel, opalescent oyster enamel,
diamonds, rubies, pearls, white onyx
Height 5³/₄″ (14.7 cm)
Surprise: Heart-shaped frame with strut forming
the name Niki (lost)
Private collection
Presented by Czar Nicholas II to his wife,
Czarina Alexandra Feodorovna
Plate 15

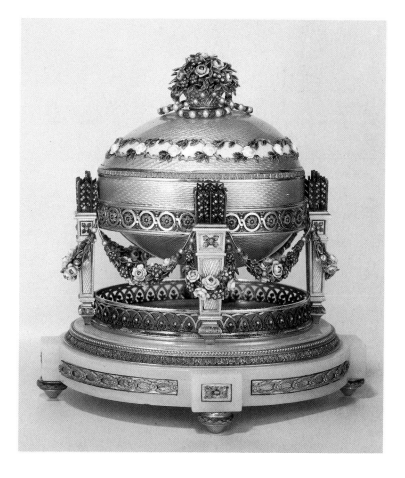

28 Swan Egg
1906
Workmaster unknown
Gold, *quatre-couleur* gold, mauve
enamel, rose-cut diamonds,
platinum, aquamarine
Height 4″ (10.2 cm)
Surprise: Clockwork swan
Heirs of the late Maurice Sandoz,
Switzerland
Presented by Czar Nicholas II
to his wife, Czarina Alexandra
Feodorovna

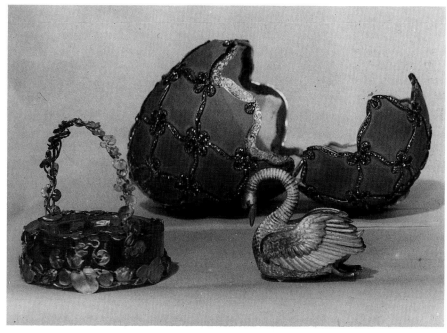

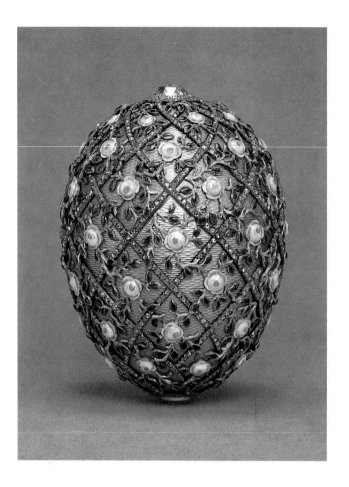

29 Rose Trellis Egg
 1907
 Henrik Wigström
 Gold, yellow, green, and pink enamel, diamonds
 Height 3¹/₁₆″ (7.7 cm)
 Surprise: Unknown
 The Walters Art Gallery, Baltimore
 Presented by Czar Nicholas II to his wife,
 Czarina Alexandra Feodorovna

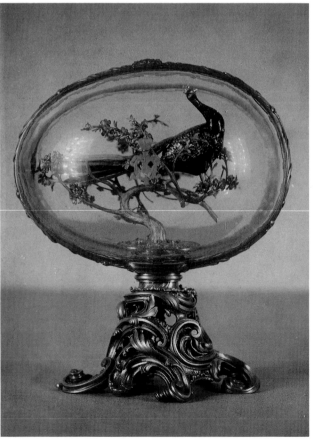

30 Peacock Egg
 1908
 Henrik Wigström
 Peacock by Dorofeev
 Rock crystal, silver-gilt, precious stones, colored
 enamel
 Height 6″ (15.2 cm)
 Surprise: Mechanical peacock
 Heirs of the late Maurice Sandoz, Switzerland
 Presented by Czar Nicholas II to his mother,
 Dowager Czarina Marie Feodorovna

31 Alexander Palace Egg
 1908
 Henrik Wigström
 Gold, silver, diamonds, rosettes, rubies, nephrite,
 rock crystal, ivory
 Height 4³/₈″ (11 cm)
 Surprise: Replica of Alexander Palace and gardens
 Armory Museum, State Museums of the Moscow
 Kremlin
 Presented by Czar Nicholas II to his wife,
 Czarina Alexandra Feodorovna
 Plate 16

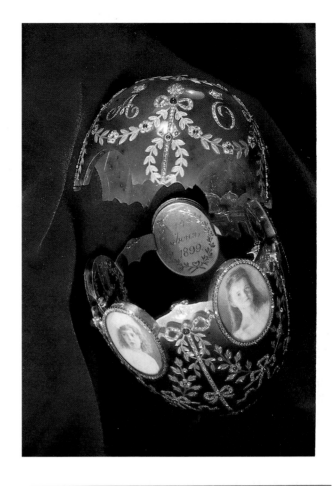

32 Standart Egg
 1909
 Henrik Wigström
 Gold, diamonds, pearls, lapis lazuli, crystal
 Height 6″ (15.3 cm)
 Surprise: Replica of imperial yacht *Standart*
 Armory Museum, State Museums of the Moscow
 Kremlin
 Presented by Czar Nicholas II to his wife,
 Czarina Alexandra Feodorovna
 Plate 17

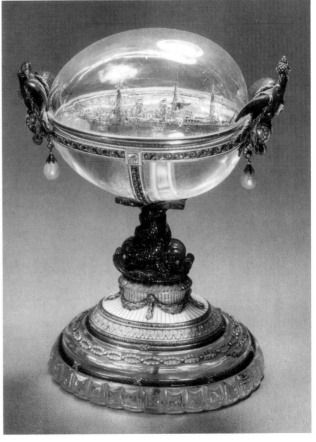

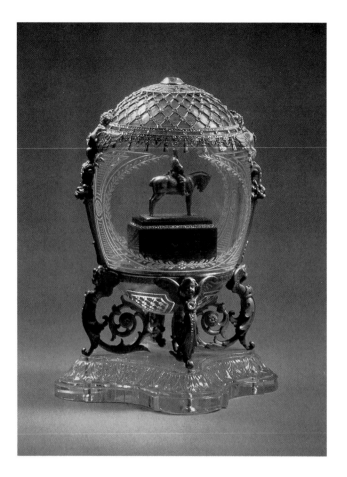

33 Alexander III Equestrian Egg
 1910
 Workmaster unknown
 Rock crystal, platinum, gold, lapis lazuli,
 diamonds
 Height 6″ (15.5 cm)
 Surprise: Replica of monument to Alexander III
 by Peter Trubetskoy
 Armory Museum, State Museums of the Moscow
 Kremlin
 Presented by Czar Nicholas II to his mother,
 Dowager Czarina Marie Feodorovna
 Plate 18

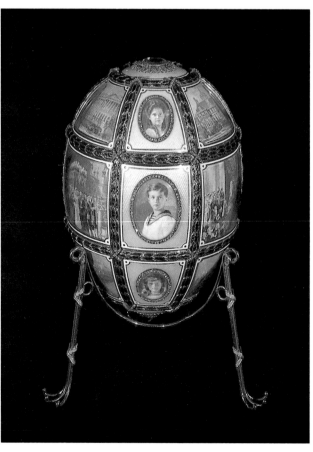

34 Fifteenth Anniversary Egg
 1911
 Henrik Wigström
 Miniatures by Vassily Zuiev
 Gold, translucent green enamel, opaque white
 enamel, opalescent oyster enamel, diamonds, rock
 crystal, ivory
 Height 5¹⁄₈″ (13.2 cm) (without stand)
 Surprise: Unknown
 The Forbes Magazine Collection, New York
 Presented by Czar Nicholas II to his wife,
 Czarina Alexandra Feodorovna
 Plate 19

35 Orange Tree Egg
 1911
 Workmaster unknown
 Gold, translucent green and opaque white enamel,
 nephrite, diamonds, citrines, amethysts, rubies,
 pearls, agate, feathers
 Height 11³/₄″ (30 cm) (open)
 Surprise: Bird emerges singing when a particu-
 lar "orange" is turned
 The Forbes Magazine Collection, New York
 Presented by Czar Nicholas II to his mother,
 Dowager Czarina Marie Feodorovna
 Plate 20

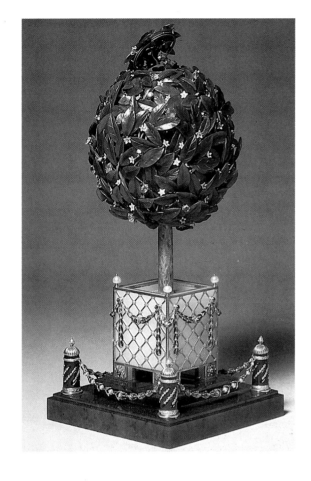

36 Napoleonic Egg
 1912
 Henrik Wigström
 Miniatures by Vassily Zuiev
 Gold, transparent emerald green and ruby
 red enamel over engine-turned ground,
 opalescent white enamel, rose-cut dia-
 monds, platinum, velvet, satin, ivory,
 gouache
 Height 4⁵/₈″ (11.8 cm)
 Surprise: Six-panel polygonal folding
 screen bearing miniatures of members of
 the czarina's regiments and the names of
 the regiments
 The Matilda Geddings Gray Foundation,
 New Orleans (New Orleans Museum
 of Art)
 Presented by Czar Nicholas II to his
 mother, Dowager Czarina Marie
 Feodorovna
 Plate 21

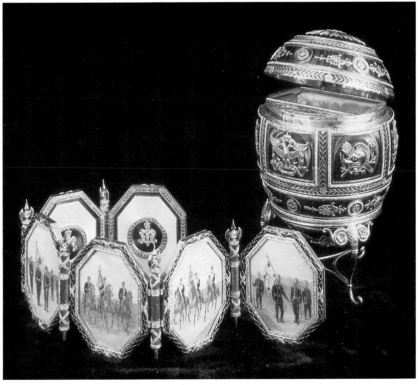

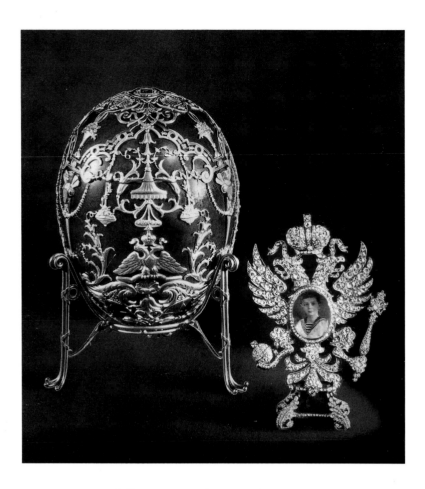

37 Czarevitch Egg
 1912
 Henrik Wigström
 Lapis lazuli, gold, diamonds, platinum
 Height 5″ (12.7 cm)
 Surprise: Pedestal supporting miniature of czare-
 vitch in frame in the shape of a double-headed eagle
 Virginia Museum of Fine Arts, Richmond, Lillian
 T. Pratt Collection
 Presented by Czar Nicholas II to his wife,
 Czarina Alexandra Feodorovna

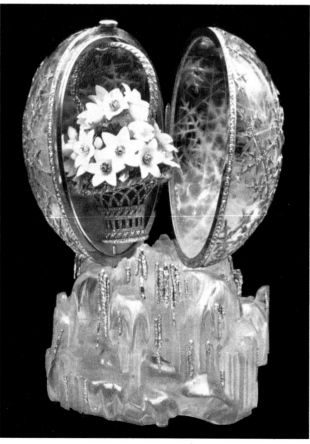

38 Winter Egg
 1913
 Workmaster unknown
 Gold, rock crystal, diamonds, platinum, olivine,
 nephrite, white quartz, moonstone
 Height 4″ (10.2 cm)
 Surprise: Basket of spring flowers
 Whereabouts unknown
 Presented by Czar Nicholas II to his mother,
 Dowager Czarina Marie Feodorovna

39 Romanov Tercentenary Egg
 1913
 Henrik Wigström
 Miniatures by Vassily Zuiev
 Surprise: Rotating globe showing territories of
 Russia in 1613 and 1913
 Gold, silver, steel, diamonds, turquoise, crystal,
 purpurine, ivory
 Height 7¹/₂″ (19 cm)
 Armory Museum, State Museums of the Moscow
 Kremlin
 Presented by Czar Nicholas II to his wife,
 Czarina Alexandra Feodorovna
 Plate 22

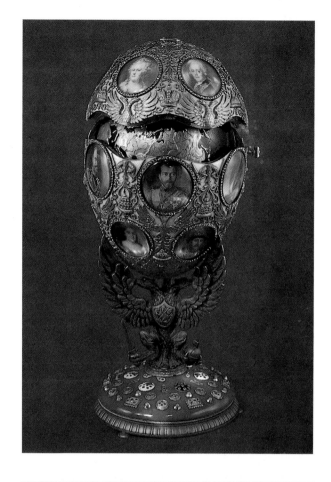

40 Grisaille Egg
 1914
 Henrik Wigström
 Miniatures by Vassily Zuiev
 Gold, *quatre-couleur* gold, translucent pink and
 opaque white enamel, rose-cut diamonds, pearl
 Height 4³/₄″ (12 cm)
 Surprise: Lost (possibly sedan chair automaton)
 Hillwood Museum, Washington, D.C., Marjorie
 M. Post Collection
 Presented by Czar Nicholas II to his mother,
 Dowager Czarina Marie Feodorovna

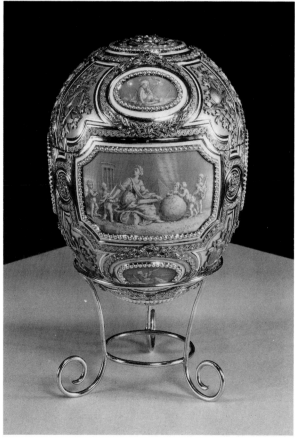

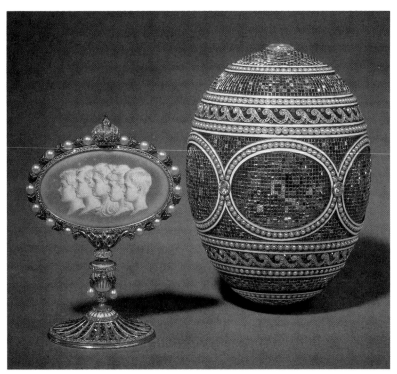

41 Mosaic Egg
1914
August Holmström
Yellow gold, platinum, diamonds, rubies,
emeralds, topazes, sapphires, garnets, pearls
Height 3⁵/₈″ (9.2 cm)
Surprise: Pedestal supporting plaque bearing pro-
files of five imperial children, their names, a basket
of flowers, and the date 1914
Her Majesty Queen Elizabeth II
Presented by Czar Nicholas II to his wife,
Czarina Alexandra Feodorovna
Plate 23

42 Red Cross Egg with Imperial Portraits
1915
Henrik Wigström
Silver-gilt, opalescent white and red enamel, gold,
mother-of-pearl
Height 3¹/₂″ (8.8 cm)
Surprise: Five-panel folding screen bearing mini-
atures of female members of the imperial family
in Red Cross uniform
Virginia Museum of Fine Arts, Richmond, Lillian
T. Pratt Collection
Presented by Czar Nicholas II to his mother,
Dowager Czarina Marie Feodorovna

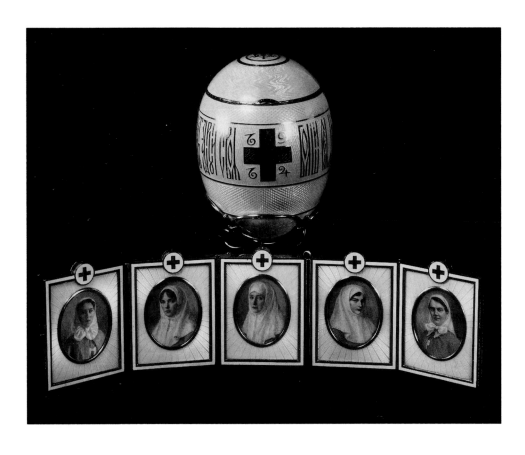

43 Red Cross Egg with Resurrection Triptych
 1915
 Henrik Wigström
 Icons by Prachov
 Gold, silver-gilt, white transparent enamel over
 engine-turned ground, red transparent enamel
 Height 3³/₈″ (8.6 cm)
 Surprise: Triptych showing The Harrowing
 of Hell (center), Princess Olga (left), and Saint
 Tatiana (right)
 The Cleveland Museum of Art, India Early
 Minshall Collection
 Presented by Czar Nicholas II to his wife,
 Czarina Alexandra Feodorovna
 Plate 24

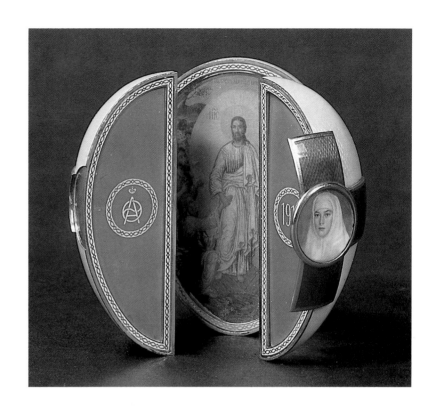

44 Steel Military Egg
 1916
 Henrik Wigström
 Miniature by Vassily Zuiev
 Gold, steel, nephrite
 Height 6¹/₂″ (16.7 cm)
 Surprise: Easel bearing the czarina's monogram
 and displaying miniature of the czar and his son at
 the Front
 Armory Museum, State Museums of the Moscow
 Kremlin
 Presented by Czar Nicholas II to his wife,
 Czarina Alexandra Feodorovna
 Plate 25

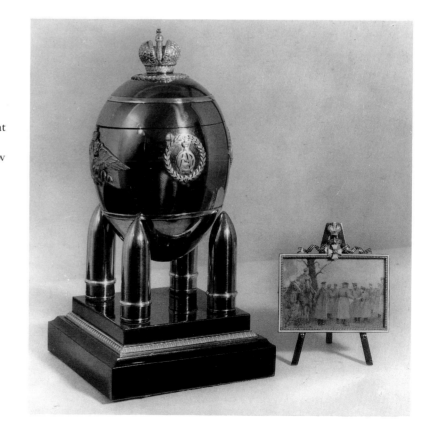

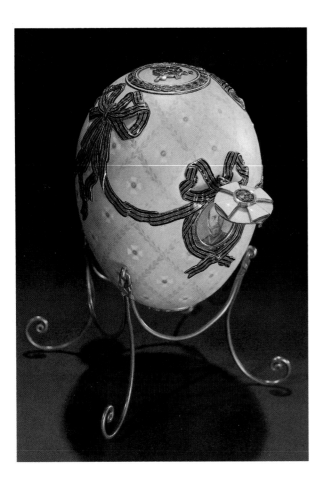

45 Cross of St. George Egg
 1916
 Workmaster unknown
 Silver, gold, translucent orange, opalescent white,
 opaque rose, pale green, white, and black enamel,
 rock crystal, ivory
 Height 3½″ (9 cm) (without stand)
 Surprise: Miniatures of the czar and czarevich are
 revealed when buttons below badge and medal of
 Order of St. George are pressed
 The Forbes Magazine Collection, New York
 Presented by Czar Nicholas II to his mother,
 Dowager Czarina Marie Feodorovna
 Plate 26

*Opinions vary as to the precise number of imperial
Easter eggs created by the house of Fabergé. The
imperial provenance of the following eggs has not been
established beyond doubt.*

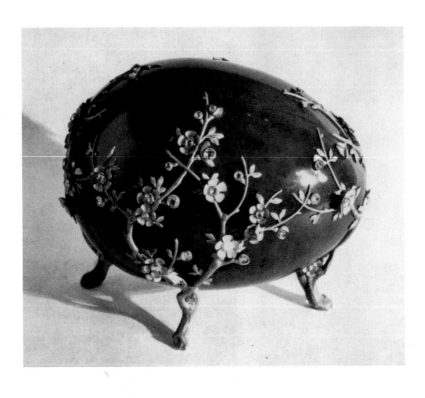

46 Apple Blossom Egg
 1901
 Michael Perchin
 Nephrite, gold, green and red gold, pink enamel,
 diamonds
 Length 4⅜″ (11 cm)
 Surprise: Lost
 Private collection, U.S.A.
 Presented by Czar Nicholas II to his mother,
 Dowager Czarina Marie Feodorovna (?)

47 Chanticleer Egg
 1903
 Michael Perchin
 Gold, green and red gold, yellow, blue, green, red,
 orange, and white enamel, diamonds, pearls,
 crystal
 Height 12⅝″ (32 cm)
 Surprise: Chanticleer emerges crowing and flap-
 ping its wings to mark the hour
 The Forbes Magazine Collection, New York
 Presented by Czar Nicholas II to his mother,
 Dowager Czarina Marie Feodorovna (?)

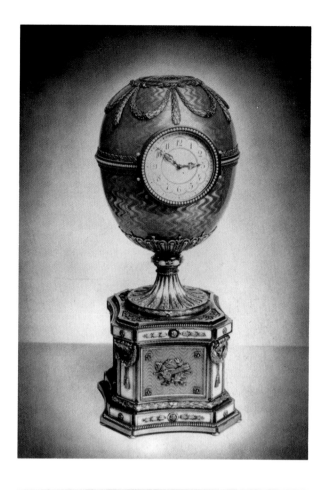

48 Twilight Egg
 1917
 Henrik Wigström
 Gold, lapis lazuli, *paillons,* diamonds, moonstone
 Height 5⅞″ (14.8 cm)
 Surprise: Unknown
 Private collection
 Presented by Czar Nicholas II to his wife,
 Czarina Alexandra Feodorovna (?)

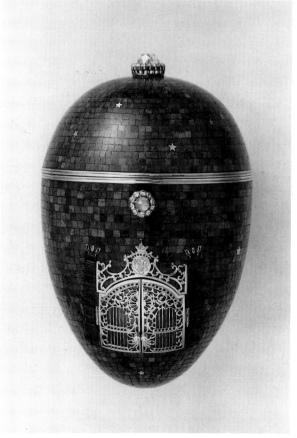

Workmasters, Craftsmen,
and Painters at the House of Fabergé

AUGUST HOLMSTRÖM
(1829-1903)

Holmström was appointed chief jeweler by
Gustav Fabergé in 1857.

KONSTANTIN KRIJITSKI

Krijitski painted miniatures for the Cau-
casus Egg and the Danish Palace Egg (plates
3, 6; nos. 8, 11, pp. 95, 97).

MICHAEL PERCHIN
(1860-1903)

Perchin is the most famous of Fabergé's
workmasters. He was responsible for the
crafting of the imperial Easter eggs from
1885 or 1886 until his death in 1903 (plates
1-13; nos. 2-24, pp. 92-103). His hallmark
appears on all but the first egg made during
those years. Although he was initially
trained by rural craftsmen, Perchin's mature
work recalls elements of the rococo and
Louis XV styles.

PRACHOV

Prachov painted the icon of the Resurrec-
tion of Christ for the Red Cross Egg with
Resurrection Triptych (plate 24; no. 43,
p. 113).

WILHELM REIMER
(d. circa 1898)

Reimer made small enamel and gold objects
(see plate 31).

HENRIK WIGSTRÖM
(1862-1923)

Wigström became head workmaster upon
Michael Perchin's death in 1903, thereby
assuming responsibility for the imperial
Easter eggs. Wigström was particularly
adept at designing cigarette boxes, frames,
and figurines, which were produced in large
numbers during the firm's most productive
years. Wigström's style is characterized by
echoes of the Louis XVI and Empire periods.

JOHANNES ZEHNGRAF
(1857-1908)

Zehngraf was the chief miniature painter
for Fabergé and decorated the Lilies of the
Valley Egg (plate 8; no. 15, p. 99).

VASSILY ZUIEV
(active 1908-1917)

Zuiev possibly succeeded Zehngraf as chief
miniature painter and painted on enamels
as well as ivory. An important example of
his work is the Fifteenth Anniversary Egg
(plate 19; no. 34, p. 108).

Glossary

bowenite

Pale green milky serpentine.

brilliant cut

A circular cut for diamonds with a flat top.

cabochon

A plain, convex cut for gemstones, often used by Fabergé for sapphires, rubies, and emeralds as accents or finials.

chasing

Detailed working of raised metal surfaces with hammer and punches on the front of the metal plate.

citrine

Yellow translucent quartz.

crossed anchors and scepter

Official gold mark for the City of St. Petersburg Standard Board, abandoned around 1896 in favor of the kokoshnik.

demantoid

Transparent green andradite used as semiprecious stone.

double-headed eagle

Symbol of the imperial Russian family; designates royal appointment when found on Fabergé objects.

engine-turning

Patterned engraving on a metal surface, also called guilloché. Often covered with layers of translucent enamel.

gold

In combination with small amounts of copper, silver, and other metals can be made to produce red, yellow, green, or white gold; when all four colors are used in a single object, the technique is referred to as *quatre-couleur* or varicolored gold.

guilloché

More than 140 patterns of curving parallel lines used by Fabergé under translucent enameled surfaces. See also *engine-turning*.

hallmark numbers

Used to designate the Russian gold and silver standards; 96 *zolotniks* of gold is equal to 24 carats; the most common alloys of 56 and 72 are equal to 14 and 18 carats.

heliotrope

Dark green chalcedony with red specks, from India.

kokoshnik

Hallmark showing a woman's head in profile wearing a traditional Russian crescent-shaped headdress called a kokoshnik, used in Russia at the end of the czarist regime.

lapis lazuli

Deep blue opaque limestone, from Siberia or Afghanistan.

mother-of-pearl

Iridescent inner layer of shells which can be carved or turned.

nephrite

Dark green jade from Siberia often used by Fabergé for frames and carved objects.

paillon

Reflective metal foil used under a layer of enamel.

purpurine

Dark red stonelike glass manufactured at the imperial glass factory in St. Petersburg for use by Fabergé lapidaries.

rocaille

Scroll design characteristic of eighteenth-century rococo style.

rock crystal

Transparent quartz.

rose diamond (or rose-cut diamond)

Usually a small diamond with the top cut into triangular facets.

rosette

An ornamental disk resembling a rose.

silver-gilt

Silver overlaid with a thin layer of gold.

table-cut diamond

A thin, rectangular diamond cut with a flat top surface.

workmaster

Highly skilled craftsman, allowed in Fabergé's St. Petersburg shop to sign work with their own initials.

Selected Bibliography
and Exhibitions

Andrews, 1983
Andrews, Peter. *The Rulers of Russia.* Chicago, 1983.

Armory, 1964
The Armory. Moscow, 1964.

Bainbridge, 1933
Bainbridge, Henry Charles. *Twice Seven.* London, 1933.

Bainbridge, 1949/66
Bainbridge, Henry Charles. *Peter Carl Fabergé: Goldsmith and Jeweller to the Russian Imperial Court, His Life and Work.* London, 1949; 2nd ed., London, 1966.

Baltimore, 1983-84
Baltimore, The Baltimore Museum of Art. *Fabergé: The Forbes Magazine Collection.* Nov. 22, 1983-Jan. 15, 1984. No cat. (checklist).

Boston, 1979
Boston, The Museum of Fine Arts. *Imperial Easter Eggs from the House of Fabergé.* Apr. 10-May 27, 1979. No cat. (handout).

Brown, 1979
Brown, Erica. "When Easter Time was Fabergé Time." *The New York Times Magazine,* Apr. 15, 1979, pp. 64-65, 68.

Chicago, 1983
Chicago, The Art Institute of Chicago. *Fabergé: Selections from the Forbes Magazine Collection.* Nov. 1-Dec. 31, 1983. No cat. (checklist).

Coburn, 1983
Coburn, Randy Sue. "The Exquisite Toys of Carl Fabergé." *Smithsonian,* Apr. 1983, pp. 46-53.

Detroit, 1984
Detroit, The Detroit Institute of Arts. *Fabergé: The Forbes Magazine Collection.* June 27-Aug. 12, 1984. No cat. (checklist).

Donova, 1973
Donova, Kira V. "Works of the Artist M. E. Perchin." In *Materials and Research.* Moscow, 1973.

Feifer, 1983
Feifer, Tatyana. "Fabergé: Jewel Maker of Imperial Russia." *Art & Antiques,* May-June 1983, pp. 90-97.

Forbes, 1979
Forbes, Christopher. "Fabergé Imperial Easter Eggs in American Collections." *Antiques,* June 1979, pp. 1228-42.

Forbes, 1980
Forbes, Christopher. *Fabergé Eggs: Imperial Russian Fantasies.* New York, 1980.

Forbes, 1986
Forbes, Christopher. "Imperial Treasures." *Art & Antiques,* Apr. 1986, pp. 52-57, 86.

Forbes, 1987
Forbes, Christopher. "A Letter on Collecting Fabergé." *The Burlington Magazine,* Sept. 1987, pp. 10-16.

Forbes, 1988
Forbes, Christopher. "Forbes' Fabulous Fabergé." *USA Today,* July 1988, pp. 36-43.

Fort Worth, 1983
Fort Worth, The Kimbell Art Museum. *Fabergé: The Forbes Magazine Collection.* June 25-Sept. 18, 1983. No cat. (checklist).

Funck, 1986
Funck, Hans Joachim. *Gold.* Frankfurt am Main, 1986.

Goldberg et al., 1967
Goldberg, Tatiana, Fedor Mishkov, Nina Platonova, and Marina Postnikova-Loseva. *Russian Gold and Silver of the XV-XX Centuries.* Moscow, 1967.

Habsburg, 1977
Habsburg, Geza von. "Carl Fabergé: Die glanzvolle Welt eines königlichen Juweliers." *Du,* Dec. 1977, pp. 48-88.

Habsburg, 1987
Habsburg, Geza von. *Fabergé.* Geneva, 1987.

Habsburg and Solodkoff, 1979
Habsburg, Geza von, and Alexander von Solodkoff. *Fabergé: Court Jeweller to the Tsars.* New York, 1979.

Helsinki, 1980
Helsinki, The Museum of Applied Arts. *Carl Fabergé and His Contemporaries.* Mar. 16-Apr. 8, 1980.

Ivanov, 1967
Ivanov, Vladimir N. *The State Armory Chamber.* Moscow, 1964.

Kelly, 1982-83
Kelly, Margaret. "Frames by Fabergé in the Forbes Magazine Collection." *Arts in Virginia,* 1982-83, pp. 2-13.

Kelly, 1985
Kelly, Margaret. *Highlights from the Forbes Magazine Galleries.* New York, 1985.

Leningrad, 1989
Leningrad, Yelagin Palace. *The Great Fabergé.* 1989.

London, 1935
London, Belgrave Square. *The Exhibition of Russian Art.* June 4-July 13, 1935.

London, 1949
London, Wartski. *A Loan Exhibition of the Works of Carl Fabergé.* Nov. 8-25, 1949.

London, 1953
London, Wartski. *Special Coronation Exhibition of the Work of Carl Fabergé.* May 20-June 13, 1953.

London, 1977
London, Victoria & Albert Museum. *Fabergé: 1846-1920.* June 23-Sept. 25, 1977. Cat. by A. Kenneth Snowman.

London, 1987
London, The Royal Academy of Arts. *The Burlington House Fair.* Sept. 9-20, 1987. No cat. (report in *The Burlington Magazine*).

Lugano, 1987
Lugano, The Thyssen-Bornemisza Collection, Villa Favorita. *Fabergé Fantasies from the Forbes Magazine Collection.* Apr. 14-June 7, 1987.

McNab Dennis, 1965
McNab Dennis, Jessie. "Fabergé's Objects of Fantasy." *The Metropolitan Museum of Art Bulletin,* Mar. 1965, pp. 229-42.

Minneapolis, 1983
Minneapolis, The Minneapolis Institute of Arts. *Fabergé: Selections from the Forbes Magazine Collection.* Apr. 3-June 12, 1983. No cat. (checklist).

Morristown, 1984
Morristown, The Morris Museum of Arts and Sciences. *Kaleidoscope Benefit.* Sept. 22, 1984. No cat.

Moscow, 1988
Moscow, Kremlin. *New Arrivals of Art Works to the State Museums of the Kremlin in Moscow.* 1988.

Munich, 1986-87
Munich, Kunsthalle der Hypo-Kulturstiftung. *Fabergé: Hofjuwelier der Zaren.* Dec. 5, 1986-Feb. 22, 1987.

New York, 1937
New York, Hammer Galleries. *Fabergé: His Works.* 1937.

New York, 1939
New York, Hammer Galleries. *Presentation of Imperial Russian Easter Gifts by Carl Fabergé.* 1939.

New York, 1949
New York, A La Vieille Russie. *Peter Carl Fabergé: Goldsmith and Jeweller to the Russian Imperial Court.* Nov.-Dec. 1949.

New York, 1951
New York, Hammer Galleries. *A Loan Exhibition of the Art of Peter Carl Fabergé, Imperial Court Jeweller.* Mar. 28-Apr. 28, 1951.

New York, 1961
New York, A La Vieille Russie. *The Art of Peter Carl Fabergé.* Oct. 25-Nov. 7, 1961.

New York, 1968
New York, A La Vieille Russie. *The Art of the Goldsmith and the Jeweler.* Nov. 6-23, 1968.

New York, 1973
New York, The New York Cultural Center. *Fabergé from the Forbes Magazine Collection.* Apr. 11-May 22, 1973.

New York, 1983
New York, A La Vieille Russie. *Fabergé.* Apr. 22-May 21, 1983.

Paris, 1987
Paris, Musée Jacquemart-André. *Fabergé: Orfèvre à la Cour des Tsars.* June 17-Aug. 31, 1987.

Richmond, 1983
Richmond, The Virginia Museum. *Fabergé: Selections from the Forbes Magazine Collection.* Feb. 9-Mar. 13, 1983. No cat. (checklist).

Rodimtseva, 1971
Rodimtseva, Irina A. *Jeweled Objects by the Firm of Fabergé.* Moscow, 1971.

San Francisco, 1964
San Francisco, M.H. de Young Memorial Museum. *Fabergé: Goldsmith to the Russian Imperial Court.* 1964.

Snowman, 1953/62/64/68/74
Snowman, A. Kenneth. *The Art of Carl Fabergé.* London, 1953; 2nd ed., London, 1962; 3rd ed., London, 1964; reprinted, London, 1968 and 1974.

Snowman, 1963
Snowman, A. Kenneth. "Lansdell K. Christie, New York: Objets d'Art by Fabergé." In *Great Private Collections,* pp. 240-49. Ed. Douglas Cooper. New York, 1963.

Snowman, 1977
Snowman, A. Kenneth. "Carl Fabergé in London." *Nineteenth Century,* Summer 1977, pp. 50-55.

Snowman, 1979
Snowman, A. Kenneth. *Carl Fabergé: Goldsmith to the Imperial Court of Russia.* London, 1979.

Snowman, 1983
Snowman, A. Kenneth. *Fabergé: Jeweler to Royalty.* New York, 1983.

Solodkoff, 1981
Solodkoff, Alexander von. *Russian Gold and Silver: 17th-19th Century.* New York, 1981.

Solodkoff, 1983
Solodkoff, Alexander von. "Ostereier von Fabergé." *Kunst & Antiquitäten,* Mar./Apr. 1983, pp. 61-67.

Solodkoff et al., 1984
Solodkoff, Alexander von, Roy D.R. Betteley, Paul Schaffer, A. Kenneth Snowman, and Marilyn Pfeifer Swezey. *Masterpieces from the House of Fabergé.* Ed. Christopher Forbes. New York, 1984.

Solodkoff, 1986
Solodkoff, Alexander von. *Fabergé Clocks.* London, 1986.

Solodkoff, 1988
Solodkoff, Alexander von. *Fabergé.* London, 1988.

Swezey, 1983
Swezey, Marilyn Pfeifer. "Fabergé and the Coronation of Nicholas and Alexandra." *Antiques,* June 1983, pp. 1210-13.

Washington, 1961
Washington, D.C., The Corcoran Gallery of Art. *Easter Eggs and Other Precious Objects by Carl Fabergé.* 1961.

Waterfield and Forbes, 1978
Waterfield, Hermione, and Christopher Forbes. *Fabergé Imperial Eggs and Other Fantasies.* New York, 1978.

Photograph Credits

Photographs were provided by the owners of the works of art, except in the following cases:

H. Peter Curran pp. 71, 93 (top)

Courtesy of R. Esmerian, Inc., New York, and Vartanian & Sons, Inc., New York pp. 63, 105 (top)

Robert Forbes p. 70 (left)

Courtesy of The Forbes Magazine Collection, New York pp. 102 (bottom), 104 (top)

Steven Mays p. 72 (top)

Olin Murphy pp. 54, 55, 100 (bottom)

D. E. Nelson p. 70 (right)

Edward Owen, Washington, D. C. p. 95 (top)

Marlen Perez, Zurich p. 87 (top right, bottom right)

Courtesy of A. Kenneth Snowman, Wartski's, London pp. 2, 15, 20-23, 29-31, 93 (bottom), 94, 95 (bottom), 97 (bottom), 98 (top), 103, 105 (bottom), 106 (bottom), 107 (bottom), 110, 111 (bottom), 112 (bottom), 114 (bottom), 115

Larry Stein pp. 18, 42 (right), 43, 47, 49, 56, 73, 96 (bottom), 99 (top), 108 (bottom)

Tree Communications, Inc., New York p. 10, 72 (bottom), 98 (bottom)

Robert Wharton, Fort Worth, Texas pp. 50, 101 (top)

The publishers would also like to thank Alexander von Solodkoff for drawing their attention to the illustration reproduced on p. 27, which has never been published in the West before.